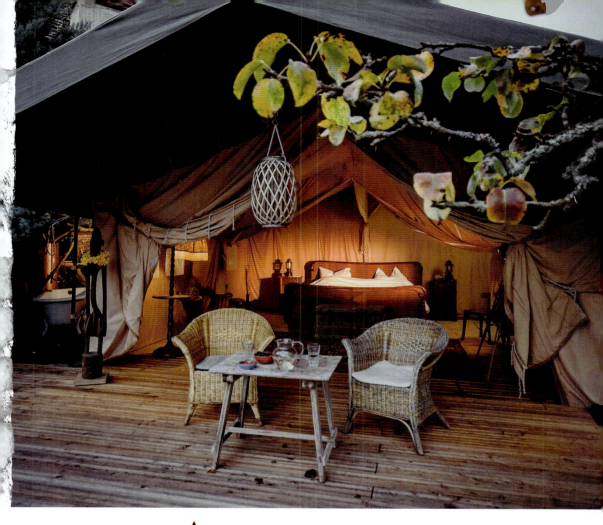

GLΛMPING

Glamorous Camping in the Great Outdoors

JULIA SCHATTAUER

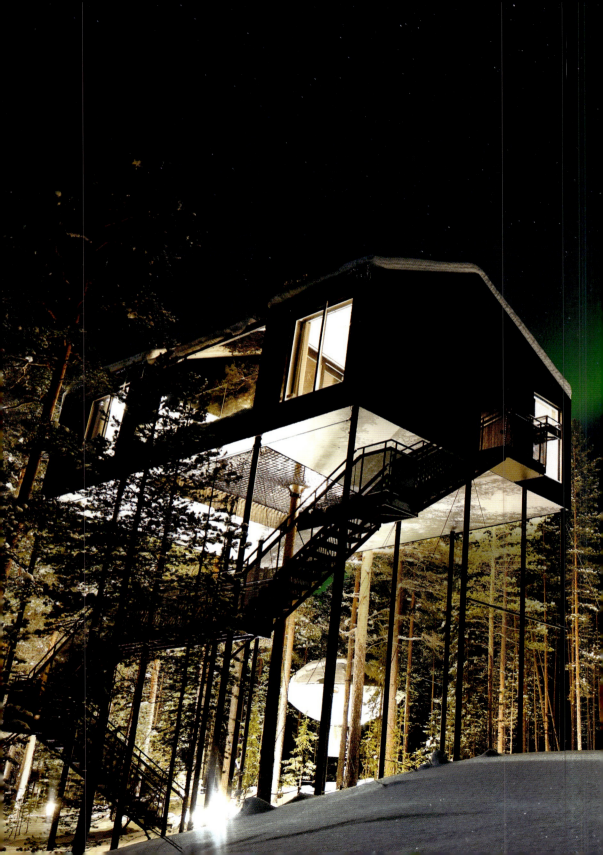

Julia Schattauer

Glamping

Glamorous Camping
in the Great Outdoors

SCHIFFER
PUBLISHING

4880 Lower Valley Road • Atglen, PA 19310

Contents

South

East

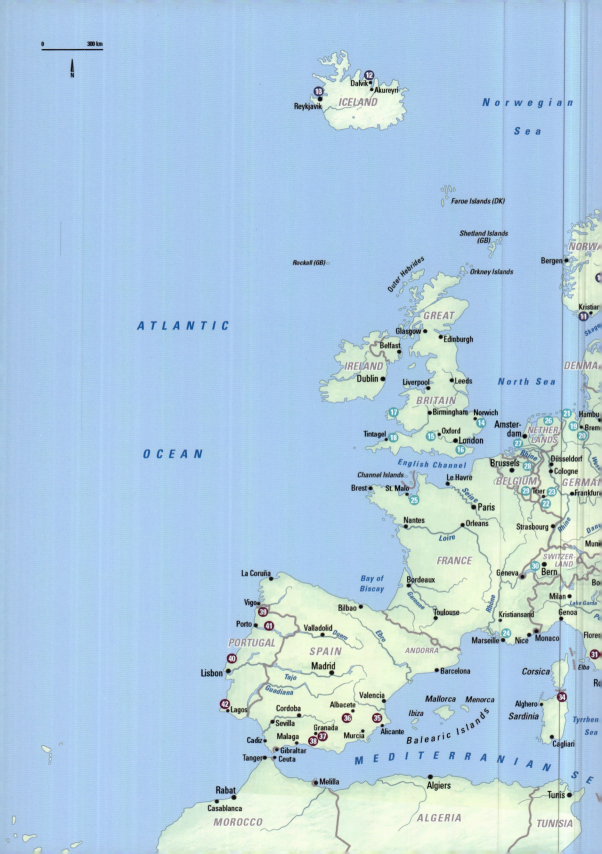

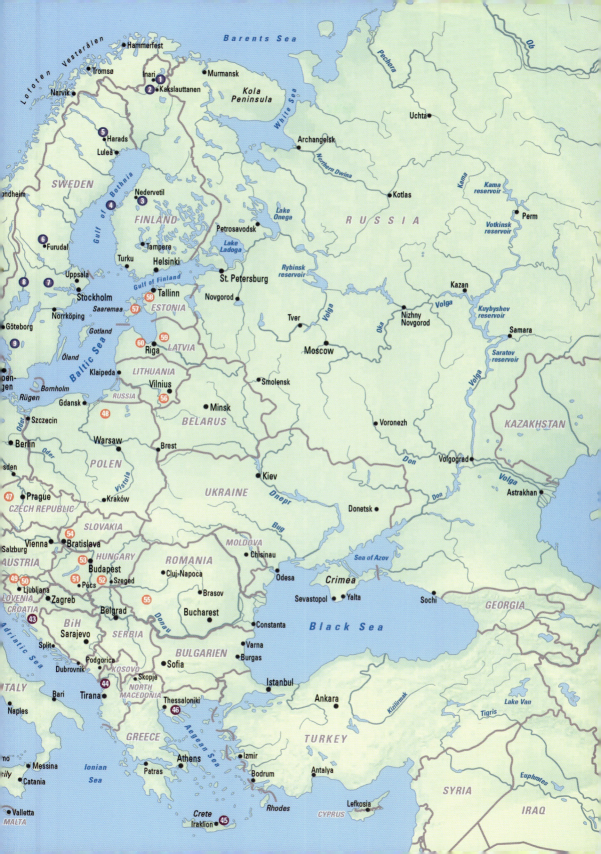

Glamping

Glamorous Camping in the Great Outdoors

A swim in the heated outdoor pool, followed by a massage, and when night falls, the two of you sit by the campfire before snuggling up in the double bed inside the tent and listening to the chirping of the cicadas while you fall asleep. Such a picture initially sounds paradoxical, but it is a trend that is finding more and more followers. This mix between the experience of camping in the wild and the comforts of a hotel room is known as "glamping." The term is a combination of "glamorous" and "camping"—glamorous camping. Glamping is perfect for those who want to be close to nature, who love to wake up to birdsong, and who prefer the scents of the forest to any perfume. But it is also for all those who do not want to camp squeezed in between fifty other caravans, and those who can easily do without cramped tents, an aching back in the morning, and communal showers that have seen better days. Unlike with camping, you won't have to carry and pitch a tent, there are no air mattresses to inflate, and you won't have to get annoyed at those rocks underneath your thin camping mat. You travel at your leisure and make yourselves right at home in your fully furnished accommodation. The feeling of adventure and freedom, of childhood dreams of tree houses come true, in combination with a few amenities such as comfortable beds, a hot tub, and room service, makes for the perfect mix of being outdoors and all modern comforts—all the ingredients needed for an unforgettable vacation in the wild.

Glamping has many different faces. These unusual and high-quality accommodations in the great outdoors take on many forms. There are luxurious safari tents where you sleep on box spring mattresses, romantic tipis deep in the forest, and traditional yurts under starry skies, quaint tree houses, and wine kegs in vineyards, but the range also includes five-star campsites with spa access. If you think glamping is only for warm summer days, think again. Even during the cold winter months, there are fabulous glamping sites offered, especially in northern Europe. A night in a glass igloo, for example. Lying in your bed, your eyes are drawn to the sky, which is illuminated with the magical display of the northern lights. During the day there is hiking in the snow and an outing on a dogsled, and in the evening a warming massage. Doesn't this sound absolutely wonderful? The typical summer locations, such as the Algarve coast in Portugal, show their lesser-known side in the winter. Everything is quiet, and the rough sea appears even more romantic.

If a vacation filled with sightseeing and club hotel accommodation, including lining up at the buffet, can sometimes be quite stressful, glamping promises plenty of room for rest and relaxation. Simply spending time outdoors, enjoying the scenery, having time together as a couple or family, and leaving the cell phone somewhere deep down in a bag can make you feel rather happy. Nature calls for mountain biking, hiking, or canoeing. Whether you are all by yourself in a tree house in Slovenia, with like-minded friends in a tent village on a farm in Portugal, or in exclusive tiny houses on a campsite in Croatia—glamping can be many things, and in the end it will always be what you make of it.

North

Inari Wilderness Hotel

Arctic with All the Works

The Arctic—the name alone conjures up feelings of adventure. We think of snow, ice, and wilderness far from civilization. The Inari Wilderness Hotel creates a wonderful symbiosis of wilderness and comfort. Here in Lapland, by the shores of Lake Inari, nature remains unspoiled and makes a perfect backdrop for a picture-book holiday in one of Finland's most remote corners. While few people live here, there are many majestic animals roaming through the woods. Reindeer, moose, foxes, and even brown bears live here. In the midst of this wilderness, the beautiful Inari Aurora Cabins are carefully embedded into the scenery. This is our favorite accommodation at the Wilderness Hotels, since there are a range of different accommodations in these hotels, like here at Inari. All of them are stylishly furnished and wonderfully cozy. The accommodations offered range from quaint and snuggly huts to spacious and luxurious holiday homes.

Heated glass roofs in the Aurora Cabins ensure the best views of the night sky at any time. Neither snow, ice, nor misted windows can spoil your sky gazing. This is certain: the Arctic sky is unlike anything you have ever seen in the sky at night before. Far from the light pollution of our cities, each star appears as if someone has put it there on purpose, just for you to enjoy—and this is even without the northern lights. But when the aurora borealis turns the sky into a canvas, the Arctic experience is complete. An indescribable moment, guaranteed to give you goose bumps, and one you will never forget. During the day, you can let off steam in the wilderness: from snowshoe hiking to snowmobile tours to husky safaris, there is everything you would expect from the Far North. Especially, the experience with the huskies is not easily forgotten. The pack barks with excitement, the air is pregnant with adrenaline, and then the powerful

The Aurora Cabins offer an uninhibited view of the night sky (*above left*).
On a snowshoe hike through the northern wintry landscape (*above right*)
Cold faces are warmed by the campfire (*below*).

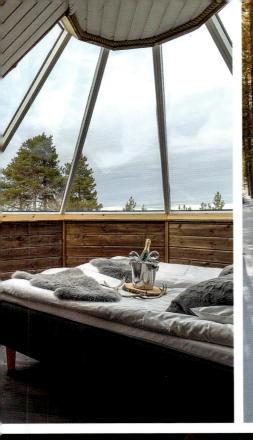
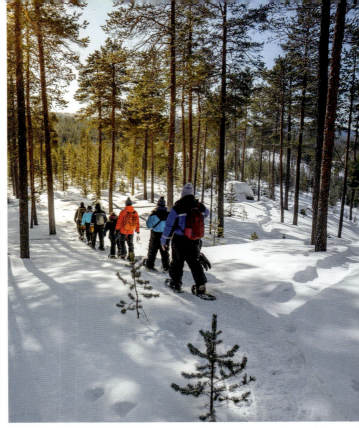
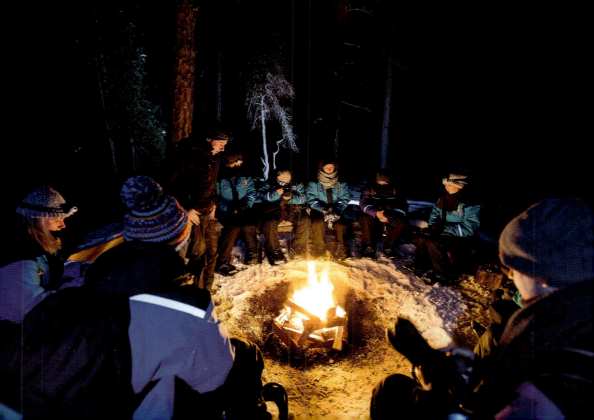

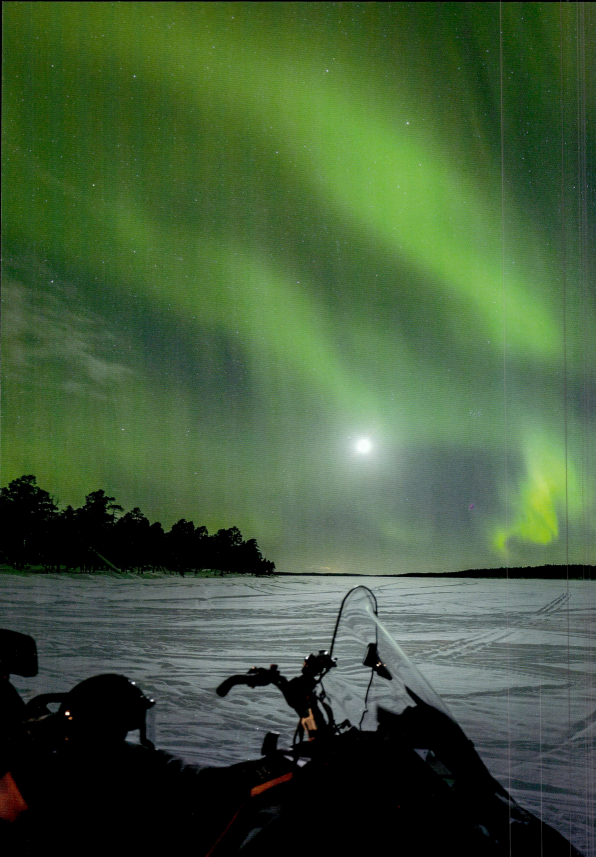

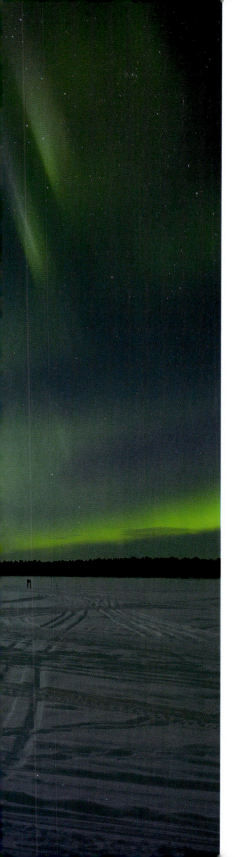

launch when the dogs start off with the sledge—a day with sled dogs is special. In the summer you will experience Lapland at a special time of year on a hike to see the midnight sun. At this time the area appears much softer and not as rough as in the winter, and the feeling of perpetual light is at least as special as the northern lights. No matter when you are here, don't forget to include a visit to neighboring Sami village. Lapland's Indigenous people provide you with a glimpse of traditional life in the Arctic Circle. Here you will become intimately acquainted with this part of the world and its people.

INSIGHTS:

To see the northern lights at their best, travel between August and April. The resort is open year-round. The nearest airport is Ivalo, less than an hour's drive by car.

Prices:
https://nellim.fi/inari/

The northern lights can be appreciated in many ways: sporty from the snowmobile, or from the comfort of your bed.

Kakslauttanen Arctic Resort

To Lapland during the Northern Lights Season

To fall asleep in the magic light of the northern lights is probably one of the most romantic experiences of traveling north. The Kakslauttanen Arctic Resort is a place for "special moments," and a night spent under the northern lights is definitely one of those. During the day, nature presents a winter wonderland, but everyone eagerly waits for the night.

Although it sounds like a good piece of storytelling, it was no marketing department that made up the story of Kakslauttanen. In 1973, the current owner, Jussi, traveled to the northernmost Finnish village on a fishing trip. On the way home he ran out of gas, and he was forced to pitch his tent where he was. Jussi felt as if he had come home—and stayed. He spent his first summer in his tent, and by the second year he had a hut and ran a coffee shop for passing travelers on the way to the North Cape. Today, the Kakslauttanen Arctic Resort has 220 accommodations, from traditional snow igloos to deluxe chalets. The most-beautiful views are from the romantic glass igloos for two people. Through the glass roof you have direct views of the firmament and—with a little luck—of the illuminations of the northern lights. No wishes remain unfulfilled here. Six restaurants serve local fare to guests. Relaxation can be found in the sauna, which is an absolute must in Finland.

Those who need a little action in addition to all the romantic stuff will find it too. Here on the Arctic sea strait and only a stone's throw away from the Urho Kekkonnen National Park, every winter dream can be fulfilled: husky tours, reindeer safaris, or even a trip with the icebreaker *Sampo*.

INSIGHTS:

The family run hotel Kakslauttanen is situated 155 mi. (250 km) north of the Arctic Circle in Finnish Lapland. The nearest international airport, in Ivalo, is only 18.6 mi. (30 km) away. The glass and snow igloos can be booked during the northern lights season from the end of August until the end of April.

Prices:

https://www.kakslauttanen.fi/

A canoe river tour in the fall (*above left*)
On a reindeer safari you will meet local herdsmen and their animals (*above right*).
Glass igloos in the Arctic snow world (*below*)

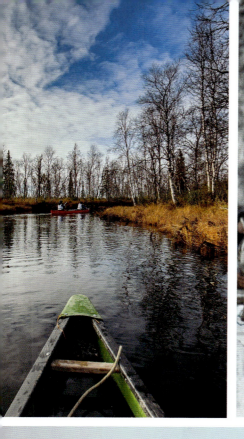
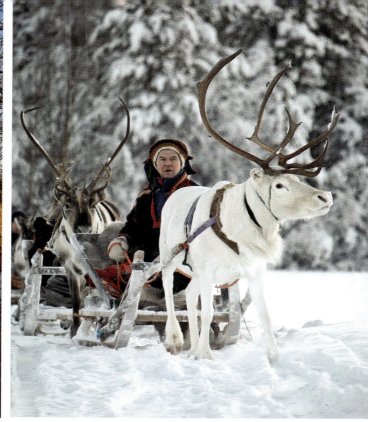
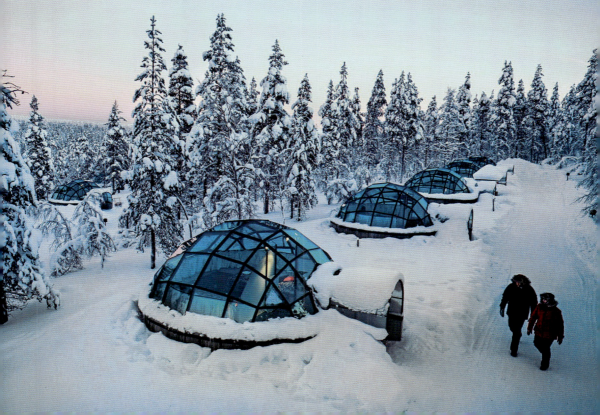

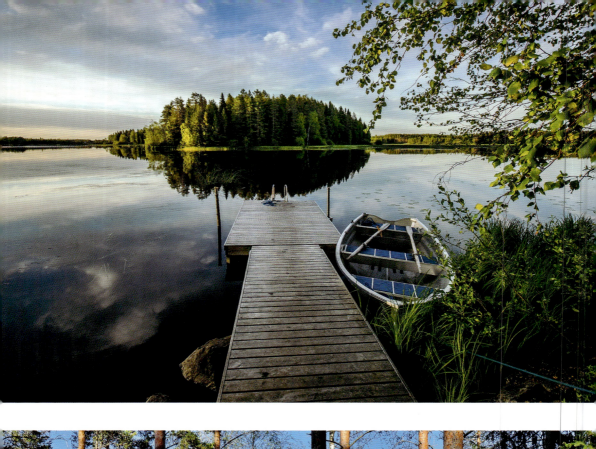
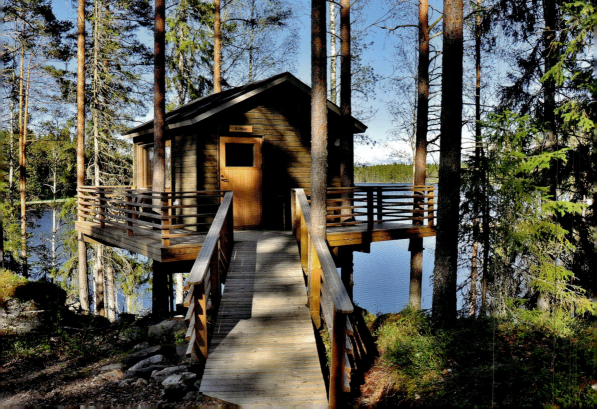

FINLAND

Emme's Retreat

Finding Soul Space in Österbotten

Even those with keen ears will not hear much. And that is exactly what we love so much about this area in western Finland. After a morning meditation, we go for sun salutations in the yoga pavilion and enjoy the Finnish sauna with lake views in the evening. In between we go for long walks through the woods and fields. This is perfect relaxation, and we can literally hear our souls starting to purr. The historical region Österbotten, on the Finnish coast, is bilingual and historically strongly shaped by Sweden. More than half the population speaks Swedish; the rest speaks Finnish. The flat landscape is fertile and crisscrossed with rivers ideal for kayaking tours.

Emme's Retreat has room for ten people in three different tree houses. Those who prefer it even more minimalistic than that can spend a night in a tree tent. Treehouse Ovan (*ovan* means "above" in Swedish) can even be reached via a ramp, completely wheelchair accessible. The little house high up in the treetops has a patio on three sides. The views across the lake and the surrounding countryside are fantastic. If you grab a mug of tea or coffee at dawn and get comfortable here, you are sure to begin the day with a smile and the glowing sun on your face. To be totally in the moment, to experience nature fully, is surprisingly easy in a place like this. Those who need even more relaxation can book a massage session with the owner, Ulla-Beth.

INSIGHTS:

Emme's Retreat is open from mid-April through early October. The nearest airport is Kokkola-Pietarsaari. A train connects Kokkola with the accommodations.

Prices: 🪙
https://www.emmesretreat.fi/

Lake and forests invite for extended walks (*above*).
Treehouse Ovan is wheelchair accessible (*below*).

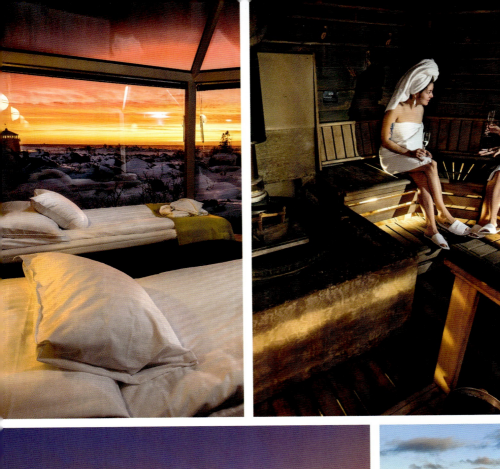

Kalle's Inn

Nights to Remember

At the end of the road, beyond civilization, there is an exclusive jewel called Kalle's Inn, on the Gulf of Bothnia. Here you will get a fair share of the glamorous side of glamping—the resort leaves no wish unfulfilled. But the best comes at the end of the day: lying on your bed, under the glass roof, you have the most-spectacular views of the night sky, depending on the season: painted vividly by the northern lights in winter and illuminated brightly by the midsummer sun in the summer. Each so beautiful that you will not want to close your eyes.

The western coast of Finland is rough and pristine, but it is equally permeated by peace and tranquility. The Kvarken Archipelago spans 50 mi. (80 km) between Finland and Sweden and is part of the UNESCO world heritage natural site. The land mass of the archipelago rises 3/8" (1 cm) farther out of the water every year. Whether it is a boating or an-

gling trip, or on a hike, here you can experience nature with all your senses. The angles of the rock edges, the turbulent waters of the Baltic, and the green of the trees create a distinct and wholesome scenery. Savoring local food is a perfect way to get to know an area better, and this is no different in Karven. Kalle's Inn helps you do this by putting regional specialties made from local ingredients on the dinner menu. Baltic herring, bass, and salmon, but also moose and reindeer. Sea buckthorn, which grows plentifully here, also appears on the plate, and the many different types of berries are used in various dishes. A special culinary experience!

If you need a bit more of a spa experience, using the sauna before bed is highly recommended. The serenity of the area finds its expression in the traditional sauna. A Finnish smoke sauna is heated by a woodburning stove that creates a warm, humid air that will relax you

The sky takes center stage here (*above left*). A visit to the sauna is a must in Finland (*above right*). The glass houses leave no wish unfulfilled (*below left*). The roughness of the Finnish coastline has its own charm (*below right*).

right to the core. At Kalle's Inn you can choose between two smoke saunas and a lighthouse sauna. They all are situated directly by the sea, which is perfect for cooling off after sweating. If you find the sea too cold, you can make yourself comfortable in the whirlpool. I guarantee you that you will sleep well afterward! But before you can doze off, there is the absolute highlight yet to come: the 180-degree view from the glass huts. Sky, sea, and horizon—and all the amenities that Kalle's Inn has to offer—appear nearly superfluous. If you open the hatch you are even closer to nature. Birdsong fills the room immediately, and the pounding of the waves on the shore sounds almost meditative. The tangy perfume of the pine trees and summer flowers finds its way into the room; they are the first thing you notice in the morning.

INSIGHTS:

Kalle's Inn is open all year. The nearest airport is Vaasa, 34 mi. (55 km) away. The airport is well connected via Helsinki and Stockholm. Private transfers from the airport can be arranged.

Prices:
http://www.kallesinn.com

Solitude as a luxury. Your wilderness dreams come true here.

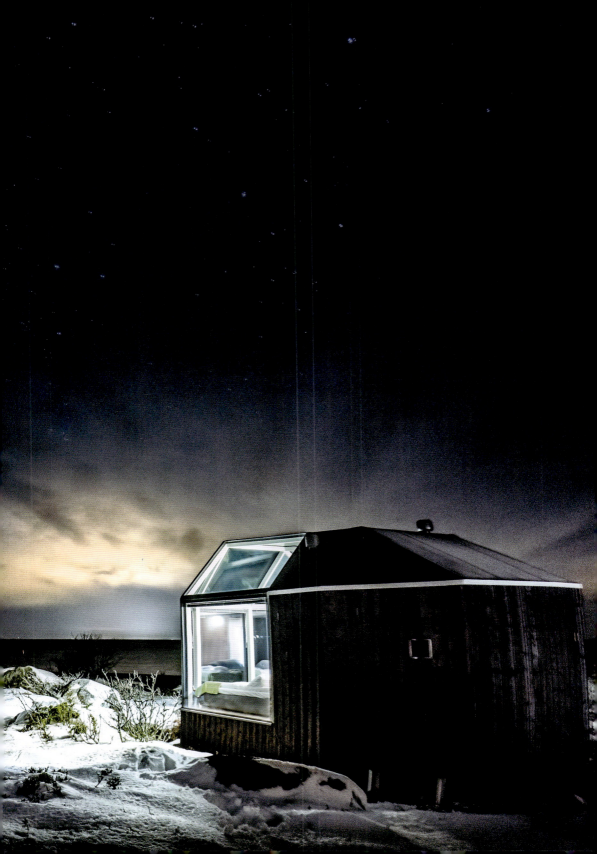

Tree Hotel

Of Dreaming Big and UFOs in the Forest

Sometimes it is the mix of the right people and the right moment that sparks the best ideas. In this case, the two main characters are Kent and Britta. Despite their successful careers, they wanted to start something in the tiny Swedish village where they grew up. They converted an empty care home into a bed-and-breakfast. When filmmaker Jonas Selberg Augustsén came to Britta's Bed & Breakfast to shoot a film called *Trädälskaren* over an entire summer, the cogs clicked into place. The tree house built for the film was much too nice to be left unused. Britta had the brilliant idea to bring the tree house and her B&B together to create a design-glamping destination. Incidentally, Kent was just at that moment on an angling trip in Russia with three top architects, and before their vacation was over they had agreed to create the perfect look for the project "design tree house." The tree hotel has grown since. Here in the north of Sweden, you can choose now among UFO, Bird's Nest, or Dragonfly, or perhaps you prefer the reflecting cube, or even the newest tree house, "The 7th room?" The latter literally tops all the other tree houses: it is more luxurious, higher, and bigger than any of the other accommodations. The seven tree houses are unique, and this news has spread abroad. The tree hotel is quite famous! No matter which of the seven you settle on, it will be an unforgettable experience. It can't get any more extraordinary as far as overnight stays go. No matter whether you love design or nature, your heart is guaranteed to skip a beat! Kent and Britta have shown that it pays to play with high stakes, and that we can turn our wildest dreams into reality, right where everything started and where our roots are.

INSIGHTS:
The prices for the tree houses vary. By car, it takes about seventy minutes from Luleå airport to the tree hotel. A transfer can be arranged. Boden C train station is about thirty-five minutes away from Harads.

Prices: 🪙
https://treehotel.se/

A romantic dinner in the forest (*above left*).
A futuristic impression: the UFO (*above right*).
A foot bridge leads to the Cabin (*below*).

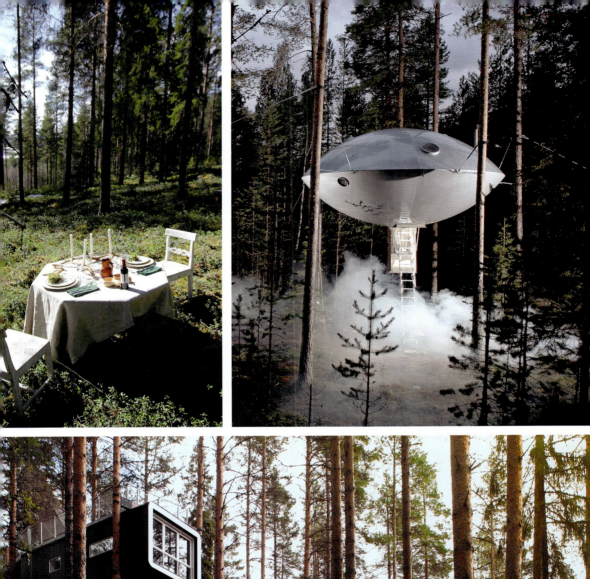
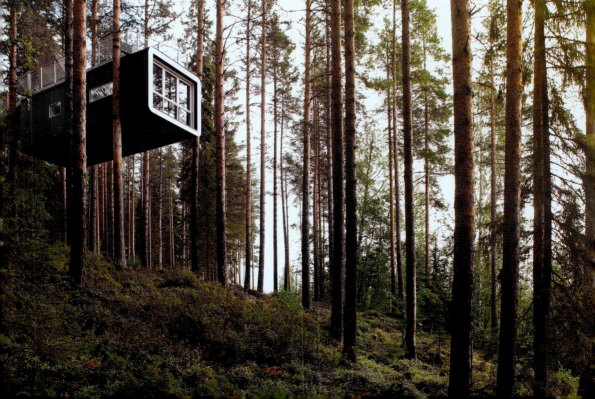

Näsets Marcusgård

Supermoon Nights

We all love the idea of a summer vacation in Sweden. In our imagination the meadows and forests of the Swedish countryside suggest endless summers, freedom, and joy. In 2014, Mireille and Willem turned their dream of life in Sweden into a reality by buying the old farm Näsets Marcusgård. Marcus Eriksson founded this farm in 1920, and even back then the farm was a meeting place for people living in the surrounding area. The new owners took up this idea and turned the old farm into a meeting place for people from all around the world. Even Pippi Longstocking would love the tree tent in the treetops of Näsets Marcusgård! This accommodation, a bright-red, round hanging tent called Supermåne 2, looks (with a little bit of imagination) like a glowing red moon. It doesn't come as a surprise then that Supermåne means "supermoon." Inside you can cuddle up and dream yourself back to your childhood. Squirrels climb past your nose, and foxes roam on the forest floor. On a walk through the forest you can discover traces of moose and lynx. No sightseeing, no leisure stress, only nature. Civilization feels pretty far away here, and that is exactly what we want, isn't it?

Apart from Supermåne, you can sleep in the whimsical tree house Oddis Öga, or in Fåhus, the former cattle shed. Whether you stay in the tree tent as a couple or in the tree house with the whole family, or you book the entire camp for your hen night with your best friends—there is the perfect accommodation for everyone here. And what can you do here? Sitting on the patio among the trees, swimming in the pool, barbecues, cuddling up with a book. For the children, there is a trampoline and a soccer pitch. And when everyone goes berry picking, snacking is mandatory! More action is not needed here. Those who do want to explore the surrounding areas a little bit more can head for idyllic Lake Siljan. Around the lake there are the bigger towns of Leksand, Rättvik, and Mora.

This quirky tree house is called Oddis Öga (*above left*). Here the forest is the playground (*above right*). Immersing yourself in Swedish traditions (*below*).

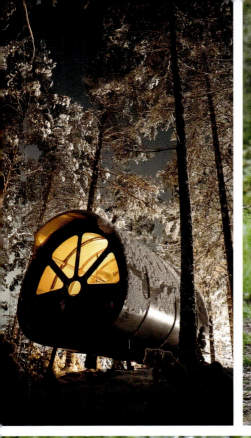
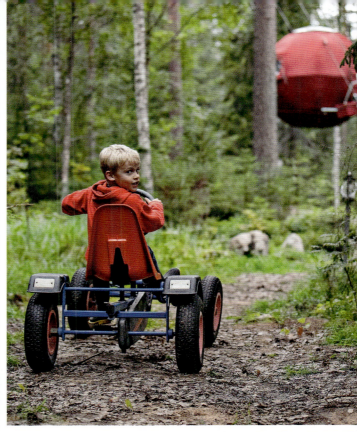

The evening comes with the lighting of campfires, even though it never gets completely dark in the summer. And how about a nighttime walk with torches through the forest afterward? And if the sun does not set at all, your nighttime walk will take you through a landscape lit by the midnight sun. If you stop and think for a moment, you will find that you are pretty close to the feeling of those childhood dreams of summers in Sweden.

INSIGHTS:

The camp is open all year, and the accommodations are heated. Näsets Marcusgård, in Furudal, is situated in Darlarnas län (province) and 23 mi. (37 km) from Mora. From Stockholm it takes three hours by train or car to get here.

Prices: 🗄
https://www.nasets-marcusgard.se

Discover the Swedish landscape from the water.

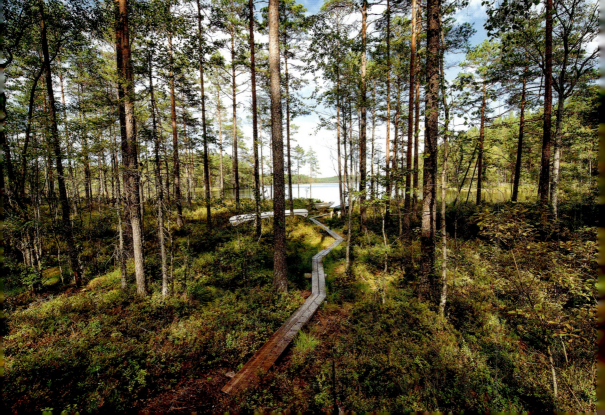

Kolarbyn Eco Lodge

Glamping for the Adventurous

The owners lovingly call it the "most primitive" hotel in all of Sweden. No electricity, no running water, no showers, no modern amenities. Instead, nothing but nature! But this is exactly what you will come to love about this place. Kolarbyn is for the adventurous and those who love nature more than anything else. This starts with the huts. Built to resemble traditional charcoal burners' huts, they are made only from natural materials. They are somewhat reminiscent of a hobbit hole and imbued with something magical. This mysterious atmosphere is what you will completely surrender to here in the forest of Bergslagen. This is your Kolarbyn adventure!

The twelve little huts will reveal themselves to you only gradually after your arrival, since they blend in perfectly with the forest around them. In the beginning the silence will seem almost noisy, until it becomes your trusted companion. In the evenings a campfire provides light, warmth, and security. Kolarbyn is a total back-to-the-roots experience. Simplicity, minimalism, and purity—we all need these from time to time. Whether you're hiking in the thick woods, fishing in the lake, or simply lying in bed in the wooden hut at night, you will be filled with something that we feel not nearly often enough: a deep satisfaction that perhaps only nature can give us. Those who want an extra dose of wilderness can participate in bushcraft survival training. More wilderness is not possible!

INSIGHTS:

Kolarbyn is in Skinnskatteberg, Västmanland. Coming from Stockholm, you reach the camp via Köping and Skinnskatteberg by train and bus in 2.5 hours. The huts with air mattresses and sheepskins are for two people; children can have extra mattresses or folding beds. One of the huts is big enough for six people. There is an additional lodge and a tree tent during the summer months.

Prices: 🪙
https://kolarbyn.se

Traditional woodland workers' fare (*above, left*). Thanks to the woodburning stoves, the huts are warm and cozy even if the nights are cold (*above right*). Kolarbyn is all about the forest (*below*).

Bluesberry Woods

A Picture-Book Vacation in Sweden

"Värmland rests by the waterside" is a Swedish saying. And no wonder, since there are 10,512 individual lakes here. Bluesberry Woods offers the picture-perfect Sweden vacation, there is no doubt about it: a lake with a jetty for swimming, bushes full of blueberries, the sun that lightens up the evenings in the summer, and a cozy place to spend the night. You only have to make up your mind—tree house or hobbit hole?

It is the simple life that makes Bluesberry Woods so special. It may sound trivial, but sometimes a swim in the lake and a campfire in the evening can make you happier than any luxuries. When we're here, we remember summer vacations as children when we fell into bed with dirty

feet and a grin on our faces, completely exhausted but happy. As adults, perhaps with children of our own, we can still enjoy all this: eating berries straight from the bush and roaming through the forest for hours. Here the evenings are spent together around the campfire while telling stories, baking pizza in the pizza oven, or playing a game of chess.

The only thing that is difficult is the decision whether to move into the tree house or the "Sculptured House." The latter accommodation blends seamlessly with the surroundings and is made from loam, moss, and other natural materials, with an emphasis on sustainability, community, and a huge dose of atmosphere. From the tree house, the scenery shows itself in the changing light; you are particularly close to the birds here, but the little house built entirely with natural materials, on the other hand, feels like a hobbit hole, cozy and safe. A place that inspires, and the "Sculptured House" is indeed occasionally rented out as an art residency to artists.

Private rooms can be as beautiful as this (*above left*).
Around the tree house there is only nature (*above right*).
At eye level with the birds (*below*).

INSIGHTS:

Despite its location in the midst of open nature, Bluesberry Woods is easy to reach. With a regional train or bus, you arrive in Bäckebron from Karlstad in half an hour. Bluesberry Woods is closed in winter.

Prices: 💰
http://bluesberrywoods.com/

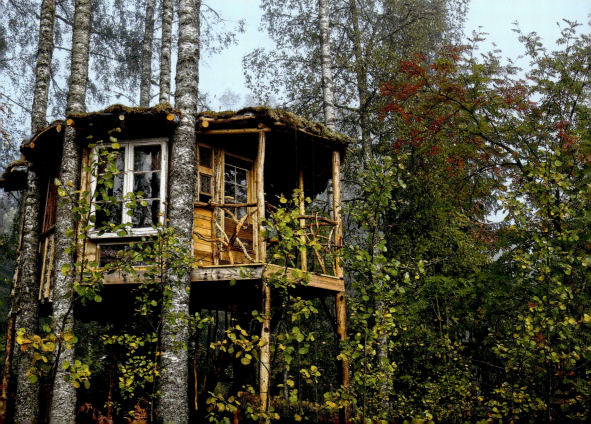

Stedsans in the Woods

Forest Supper Club

A restaurant with a regional, seasonal menu, a permaculture farm, huts for guests, and all this in the midst of the Swedish forest. Doesn't that sound too good to be true? One thing is certain: Stedsans in the Woods is more than an accommodation for getting out for a day. The proprietors call it a "laboratory for future ways of life." Everything is about living in unison with the environment, about eating better, and about showing that things can be done differently than in the past—you only have to want to change. Until a few years ago, Mette Helbæk and Flemming Hansen were running an urban restaurant on a roof terrace in Copenhagen. But both were driven by the dream to create something with a bit more depth, and eventually they arrived here in the woods of Halland. Stedsans in the Woods is located, just as the name suggests, in a remote woodland area. It combines wilderness with a cozy atmosphere, and the entire resort aims at the ultimate outdoor experience. If you come here, you should bring sturdy boots, warm socks, and a healthy dose of curiosity. I guarantee you will fall head over heels in love with this place! Everything here revolves around predominantly vegetarian food. The evening starts with a drink and a small bite at the boathouse. The Stedsans has its own fields, and produce coming from the fields goes directly into the kitchen and onto the plate. It is all about fresh food, respect for nature, reducing water consumption, zero waste, and the unadulterated good taste of the food. The food is served at large, shared tables where you can watch the cooks being busy at the fire. The perfect setting to share your impressions and experiences with other guests. Later, everyone settles down by the open fireplace, perhaps with a bottle of wine, and new friendships are effortlessly made.

The owners have exchanged city life for Swedish nature (*above left*). The ingredients for the food come directly from Stedsans' farm (*above right*). Wake up to panoramic views of the forest (*below*).

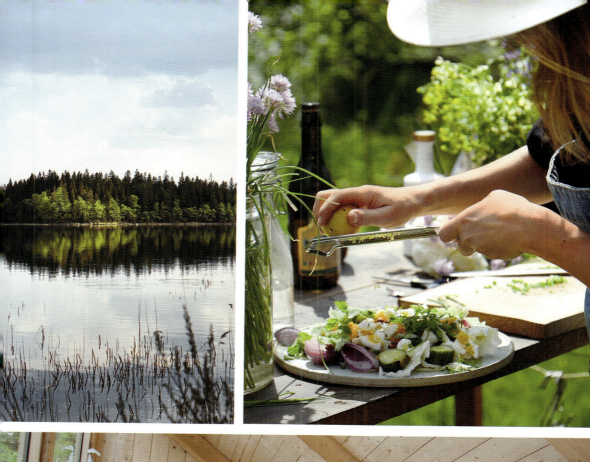
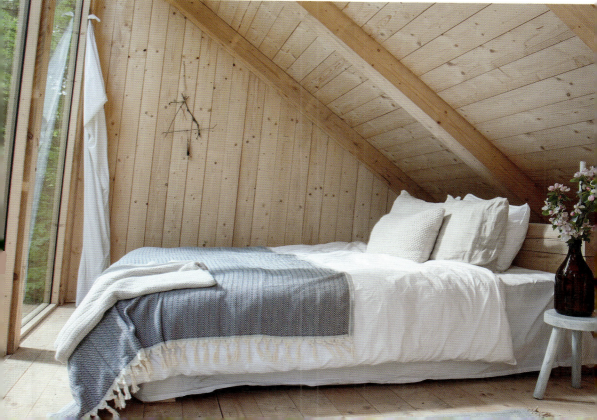

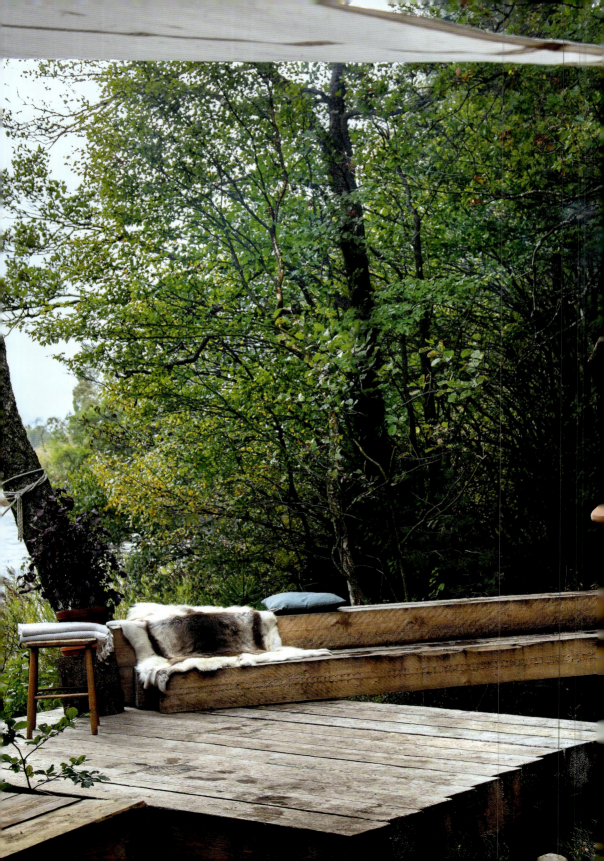

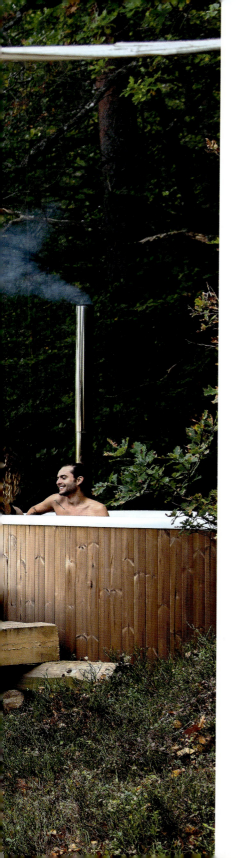

The entire place is run with purified water from Lake Halla; compost toilets, organic linen bedsheets, and towels in the huts are also part of the sustainability concept. The tiny houses are made of wood and have a huge panorama window to allow unspoiled views of nature. A cozy bed guarantees quiet and restorative nights. Apart from the huts, there is also a dormitory with hammocks for those with a smaller purse. Those who dive into this lovingly designed parallel universe witness with their own eyes that "doing things differently" is possible. It is exactly this motivation and inspiration that the owners want to give each guest—for a better future that can start very small indeed.

INSIGHTS:

The nearest airports are Copenhagen, Malmö/Sturup, and Göteborg, all of which are about 2 to 2.5 hours away from Bohult. The nearest train station is in Halmstad.

Prices:
https://www.stedsans.org/

A different way of forest bathing! In the forest spa you can relax and recharge together in the warm water.

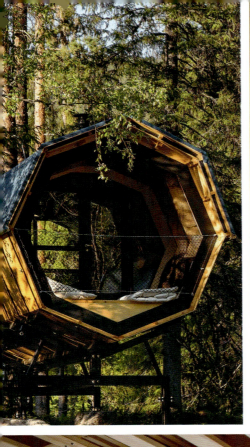
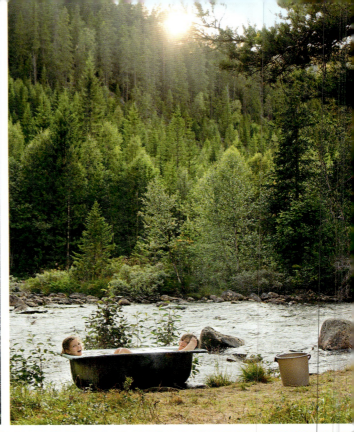
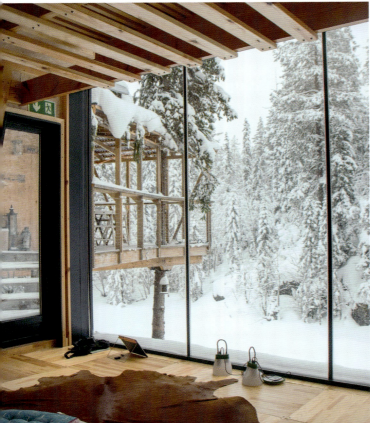
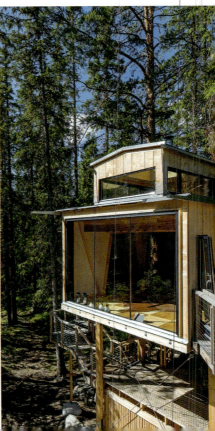

Å Camp

In the Eye of the River

The first glance upon waking up falls onto the mountain stream Tessungåe, whose rushing fills the air. Wild and furiously the crystal-clear river carves its path down from the mountains into the valley. Å *auge* means "eye of the river," and this is exactly how you feel in the tree house with the same name. High up, you are far away from everyday life and civilization. You will feel just how wonderful that is as soon as you close your eyes and surrender completely to the symphony of nature. In the midst of the Norwegian forest the Å Camp, to which the Å auge belongs, is a spectacular mix of design accommodation and wilderness. It's 100% away from the well-trodden paths, and yet only two and a half hours away from Oslo, and the tree house is a refuge for nature seekers of the special kind.

Around the Å Camp there is the unspoiled river landscape and the untouched Nordic forest. Depending on the season you can go foraging for berries or mushrooms. Hiking through the spruce and pine forest, you experience the remoteness of the Telemark woods with each breath. You don't meet a single human soul, but you find traces of animals everywhere. We don't really feel these days just how euphoric stillness can be and how good the forest is for us. Forest bathing has become a popular trend, but here you can do it in two ways at once. On the one hand, the forest invites you to really come down and unwind when you roam in the shade of the silent tree giants. On the other hand, you can quite literally have a bath in a tub in the forest. By the river there is a bathtub between the woods and the water. Nothing more than a bit of dry wood, a few buckets of warm water, a natural soap, and salt are needed for this spa experience.

High above the mountain stream (*above left*). How about a bath in nature (*above right*)? In the winter it gets particularly cozy (*below left*). Large windows give much light (*below right*).

It takes only forty-five minutes for the water to reach the right temperature for a perfect bath, then you can sink into the pleasurably warm water.

If you'd like to explore more of the surrounding landscape, you can visit one of the biggest plateaus in Europe, the Hardangervidda. The many hiking trails up here allow you to experience the plateau in all its different aspects. If angling is your thing, you can try your luck from the riverbank or from a boat. Or you can jump into a kayak. Back in the camp you can relax in a hammock for a bit. Cooking supper in the outdoor kitchen, you get that special camping feeling. In the evening the campfire crackles, its warmth fills your whole body, and the night sky envelops you like a cozy blanket. This is freedom in Scandinavia.

INSIGHTS:

Tree house, tent, tipi, or forest hut: there are several options for accommodation in Å Camp. The camp is a 2.5-hour drive from Oslo, and Austbygde is 9.3 mi. (15 km) away.

Prices:

http://www.aacamp.no/

Summer or winter, a trip into the Norwegian woods is always fascinating.

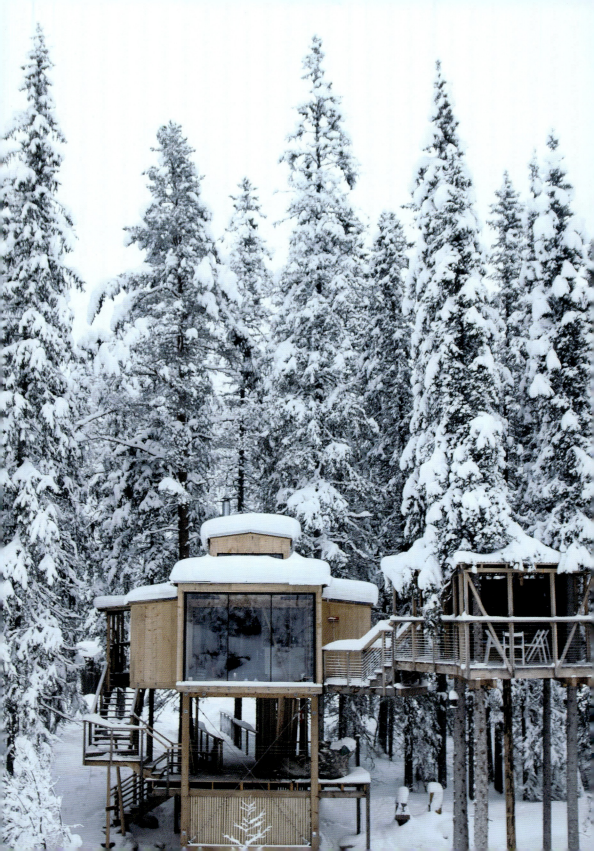

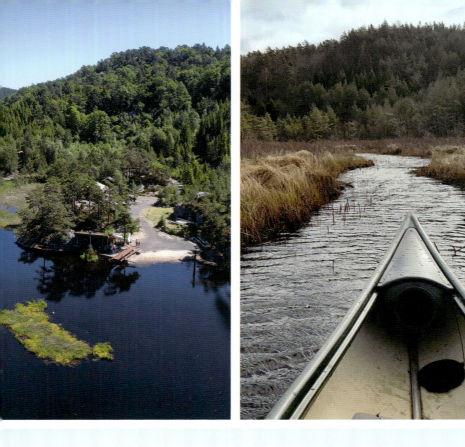
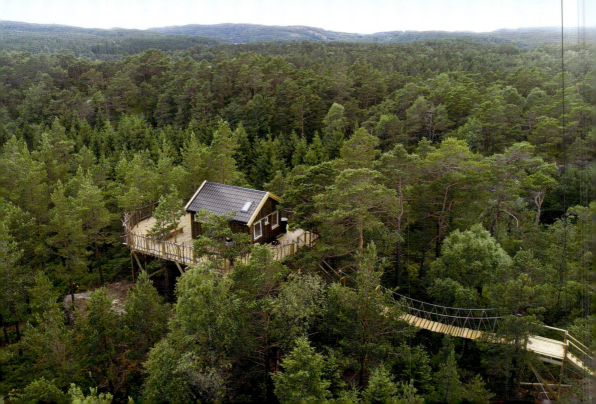

Gluba Treetop Cabins

Family Vacation among the Trees

A family vacation that everyone equally enjoys—easier said than done. But it doesn't take a lot of entertainment or gigantic club hotels to put a smile on kids' faces, and places like the Gluba Treetop Cabins are proof of that. Everyone sleeps in a roomy tree house, which is comfortable and well secured. But don't worry: you will still get that adventure feeling! You just don't sleep like this at home every night, high up among the birds' nests. The densely forested area in southern Norway is the perfect backdrop for a family vacation. Your adventure starts with your arrival. Once you've parked the car, you have to carry your bags across the footpaths for 0.6 mi. (1 km) through the woods until you reach the accommodation. Does the forest in Norway smell more strongly than at home? Arriving at the accommodation, the children will immediately find their favorite places: tree swing, hammock, and of course the tree house itself, which you enter across a suspension bridge. The next day, you take canoes to the waterfall and jump into the refreshing lake to cool down. There is even a beach where you can relax and build sandcastles. With the canoes, you can explore the canals between the small lakes. If you are lucky, you might be able to see the eagle couple or some moose. You will certainly find traces of beavers on the shore. In the evening, heating up the barbecue is a must for that perfect outdoor experience. I would bet my hat that Playstations and the like are completely forgotten!

INSIGHTS:
The accommodation has no electricity and no running water. Rainwater is collected and boiled before use. There is a gas hob and solar panels for lighting and recharging mobile phones. The tree house can be rented all year.

Prices: 💰

https://www.gluba.no/

The accommodation is directly on the shore of the lake (*above left*). Explore the local area by canoe (*above right*). The tree house offers enough space for the whole family (*below*).

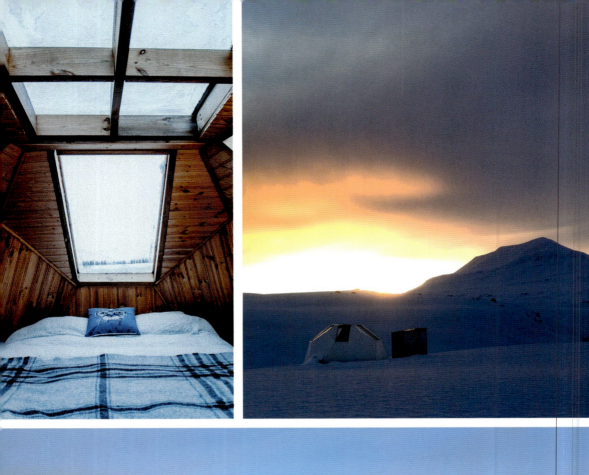
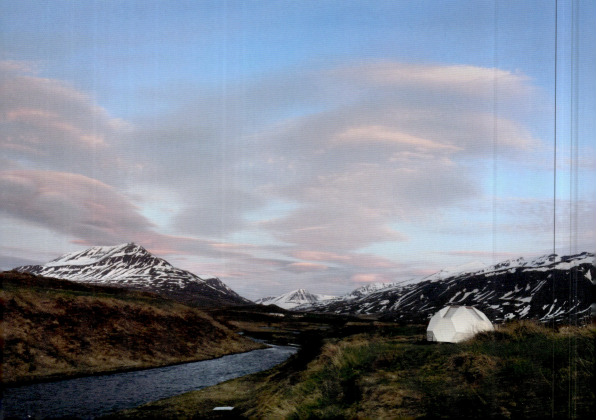

Sky-Sighting Iġlúhús

Expedition Iceland

The small settlement of Litli-Árskógs-sandur is in the farthest northeast of Iceland. The ferries to Hirsey depart from here, but it is worth staying in this area. In the middle of the wide, rural Icelandic idyll, you can experience a special night. Deeply snowed in, far from other people, you can admire the starry sky under the wooden dome of the Iglúhús. In the winter you will have to make your way through the white winter wonderland before moving into your dome for the night. The French owners dared to risk the adventure Iceland. After coming to the island in 2018, they decided to take over this accommodation in 2019. The concept is clear: no frills, just nature. Solitude, wide-open skies, and the Iceland feeling are 100% guaranteed. Doesn't that sound highly romantic? So take your favorite person and look forward to cozy hours gazing up at the stars. A comfortable bed, panoramic views, and even Wi-Fi is available in the igloo.

But the next morning, a little bit more adventure still awaits. How about a date with the biggest inhabitant of the oceans? Whale watching gives you a chance to get up close to marine mammals. But there are quite a few other things to do here besides. Everywhere in Iceland there are hot springs due to the geothermal peculiarities of the island, and Hauganes is no exception. When the sky is full of dark, heavy clouds and the air is bitingly cold, and you are sitting in the hot water, you are living that dream of Iceland you have always imagined.

INSIGHTS:

The Iglúhús in Litli-Árskógssandur offers a porch, free Wi-Fi, and river views. There is no running water and no shower. The accommodation is 21 mi. (34 km) away from Akureyri.

Prices: 🛢️
https://stay-in-arbakki.com/en/igluhus/

Looking up into the sky while you sleep (*above left*). The igloo promises solitude (*above right*). Experience picture-book Iceland far from the crowds (*below*).

Reykjavík Domes

Glamping Experience in a
Theme Park

Only a few minutes outside the city center, in the middle of a theme park—if that doesn't sound like the typical glamping experience to you, I don't blame you. But I promise, it is worth giving the Reykjavík Domes a chance.

The king-size bed is so comfortable that it is really difficult to get out of it in the morning. Then again, there is no reason at all not to stay in bed all day, particularly if the bed is under a 269 sq. ft. (25 m²) cupola as it is here. The two domes offer spectacular views into the sky and over the surrounding landscape, including snow-covered Mount Esja in the Reykjavík mountain range. Inside the dome you feel miles away from the camping grounds and the theme park. Instead you can get cozy on the soft sheepskin rugs, play a round of cards, or use the tablet provided to learn about the area in a playful way. You listen to the crackling fire and watch the moon as it rises. And when the greenish glimmer of the northern lights appears in the starry sky, everything is simply perfect.

If you do make it out of bed, you could play a round of mini golf in the theme park. Or you could book a trip to explore the natural beauty of the area; for example, the Golden Circle. How about a hiking tour on a glacier, or a visit to the Blue Lagoon?

INSIGHTS:
Only a ten-minute drive away from Reykjavík city center; a large parking area is provided. The domes are open all year; a fan heater provides additional warmth in the winter.

Prices: 🎛
https://www.reykjavikdomes.com/

From the dome you can admire the colors in the sky (*above*). Despite its location in a theme park you can find peace and solitude here (*below*).

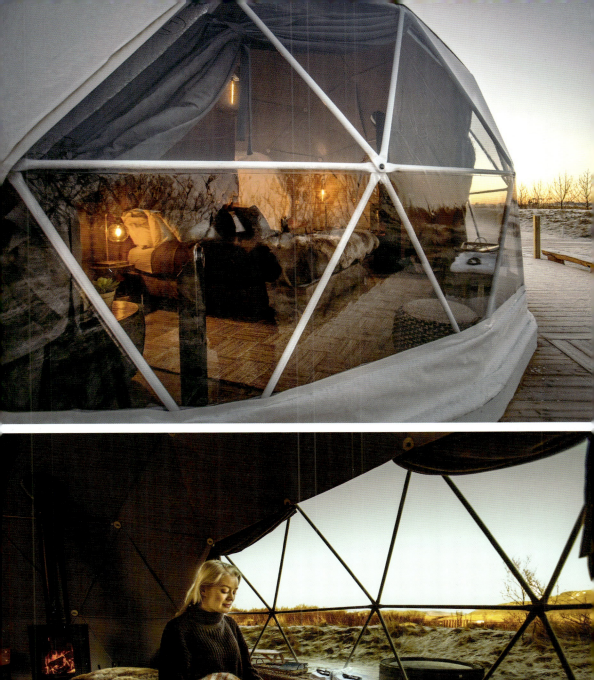
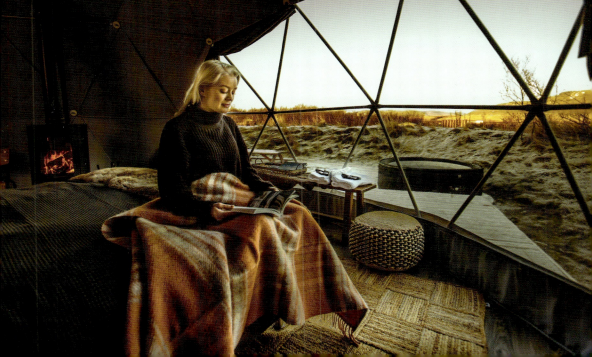

West

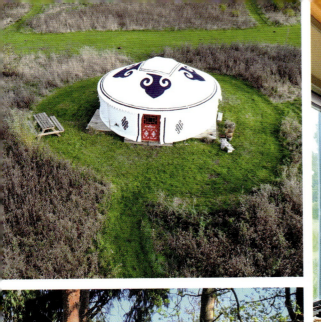

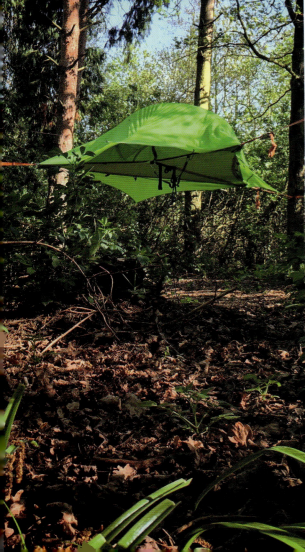

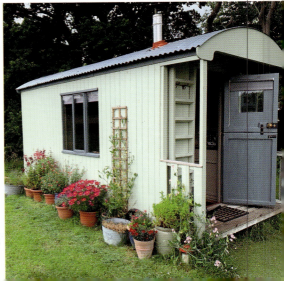

Wardley Hill Campsite

Accommodation for a Tea Party

Waveney valley, in Norfolk, is bathed in a luscious green, wildflowers dot the grass with color, and the stalks and blades are gently swaying in the wind. A river runs through the valley, and small ponds invite you to take a dip in the summer. There are a few tents on the meadow, and some children are chasing each other; a couple is watching a stunt kite cartwheeling in the sky. If you imagine the perfectly relaxed summer vacation, this is it.

Apart from the campsite, there are a range of imaginative accommodations for those who want to experience the outdoors but prefer to do so without tiny tents and thin sleeping mats. When you look at the bell tents and little houses, you feel like Alice has created her wonderland here. So, anyone for afternoon tea? Here at Wardley Hill the problem once again is how on earth to decide between these unique glamping accommodations. If you have always

dreamed of sleeping in a large, stylish bell tent, then the Lotus Belle is your choice. There is enough space for a comfortable double bed with an extra warm blanket for cooler nights. You can also take the blanket and a glass of wine outside to enjoy a nighttime drink in front of the tent on the meadow while gazing at the stars. The tent combines that camping feeling of the outdoors with a lot of space and the comforts of a hotel room.

The traditional bell tent is even more spacious, with a double bed and two singles. Here you find room for the whole family, and at night you all enjoy happy camping evenings of the special sort.

If you love the gentle swaying of a hammock, you should go for the hammock hut. In this mini house there is room for two. The charming shepherd's hut with its crackling fire is particularly cozy. The tree tent offers a special outdoor feeling. Pitched high up between two trees, you will feel suspended in the air. Get in, close the tent, and dream off.

The yurt is the traditional round tent of the nomadic people (*above right*). In the shepherd's hut the coziest spot is the alcove (*above right*). The tree tent guarantees outdoor feeling (*below left*). Comfort on wheels (*below right*).

No matter where you land within the grounds, your favorite place will put you right next to the babbling brook, the woods and meadows full of sweetly smelling wildflowers, the birdsong, and the humming of the bees. Around the grounds the Waveney Valley nature reserve invites you to explore. The river Waveney forms the border between the counties of Norfolk and Suffolk and runs only 1.5 km away past the camping site. Rent an SUP board and let yourself be mesmerized by the peaceful river scape in this motor-free stretch of the river. With a bit of luck you can see kingfishers or otter, or bass, tench, or pike in the water. And because you don't want your paddle trip to be stressful, you can book both board and transfer to the river at the campsite.

INSIGHTS:

Some of the accommodations are available only in the summer months; others can be booked all year. Once you have passed London, it takes about two hours to drive to the campsite.

Prices: 💲
https://www.wardleyhillcampsite.com/

Letting off a bit of steam and taking in wildlife and scenery at the same time is rather easily done on the river.

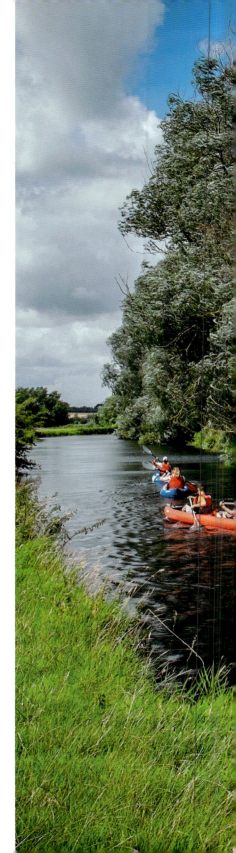

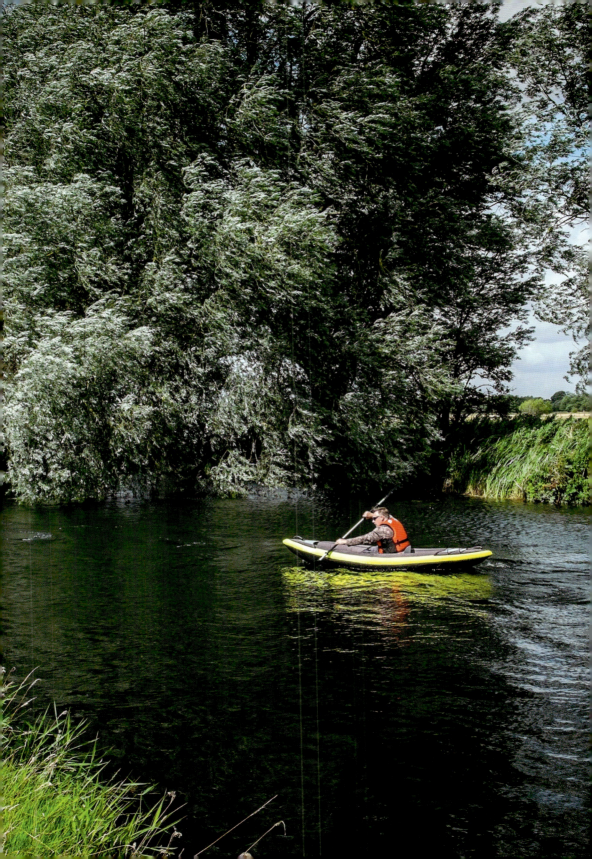

The Oxford Yurt

Boho Festival Vibes

You and your best friends all together in a yurt; you have flowers in your hair and cocktails in your hands, and the horizon is ablaze with the sunset. This is a hen party without the hawker's tray and embarrassing T-shirts. Instead, you can enjoy a carefree time in front of a backdrop that rivals any Pinterest or Instagram post. This location specializes in hen parties, as it were, but it is equally perfect for a getaway with friends. The Oxford Yurt is literally a dream come true—Sarah's dream. More than twelve years ago she stumbled across the subject of yurts and was soon head over heels in love with the atmosphere. Since then, she's not only become owner of a yurt but helps others enjoy them too. Sarah offers a range of packages, from complete parties for large groups to smaller group events. You can choose from a range of add-on activities to your party: cocktail and yoga classes, painting courses, live music, or silent disco. No matter the event for which you come to the Oxford Yurt, you will celebrate being here! Whether yurt or geodome, Sarah's decorating instincts and the right activities make for a magical, playful atmosphere on a picture-perfect meadow in Oxfordshire, with views across to the Uffington White Horse, England's oldest chalk figure.

INSIGHTS:

The grounds are only thirty minutes away from Oxford and forty minutes from London. The nearest train station is Swindon, twenty minutes by taxi. The grounds have three independent sections that can be booked separately.

Prices: 🛏️
www.theoxfordyurt.co.uk

Spend relaxing days with friends (*above*). Cozy vintage is the most fitting label for the style of the Oxford Yurt (*below*).

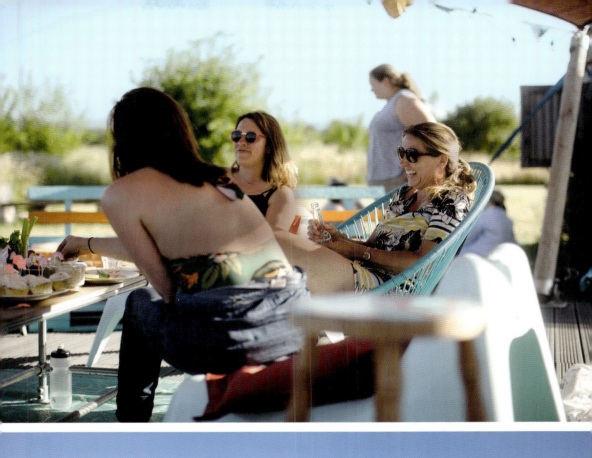
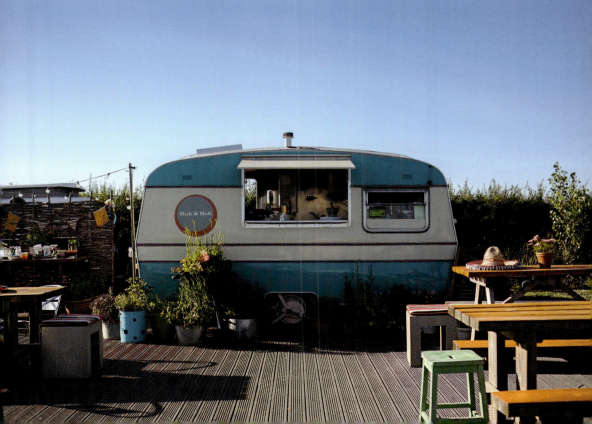

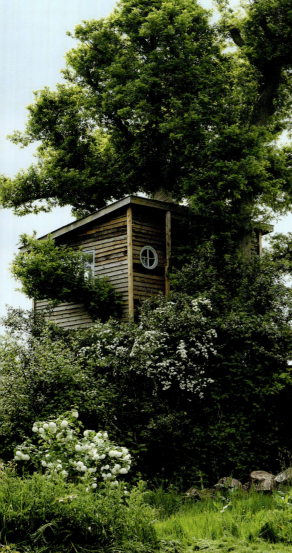

The Elham Treehouse

A Place to Enjoy the View
from the Window

Mark had once been a city person through and through; now he prefers to sit by the river with his fishing line. Mark shares his love for nature, in which everything takes a bit of a slower course, with the guests in his tree house.

The Elham Treehouse is a place made for reading, for simply gazing out the window, for being all by yourself. When was the last time you were consciously all by yourself? To many, being alone is an uncomfortable feeling. Going on vacation by yourself seems strange to many people. All too often we associate being alone with loneliness, but time spent consciously in solitude can be so good. The Elham Treehouse is the perfect place for testing out being alone. The house is situated at the end of a garden, high up between three sturdy oak trees. It was made completely from recycled wood. From here, you have a fantastic view far across the Kent Downs Area of Outstanding Natural Beauty (AONB), a protected landscape full of history and extraordinary beauty. On the edge of the barley fields, you won't hear cars or any other city noises. Instead, you will hear the wind swish through the fields, the rustling of the leaves, and the merry singing of the birds. Here you can read, listen to music, dance, write, dream, rest, be creative, or do nothing, and enjoy doing nothing. Just give yourself permission to do what you really feel like doing. Nobody expects anything from you here, and that can be such a relief. And if you do feel like company at some point, Elham has two pubs where you can meet people.

Outside the tree house you can savor solitude to the full as well. Take a stroll through the garden, sit in the grass, and feel the earth beneath you. You can walk for hours on the edge of the fields and not meet a single soul. Go for a bike ride and enjoy the luxury of hardly meeting any cars. A visit to Elham is worth it.

The grounds are spacious and full of English charm (*above left*). In the spring, the lilac bushes delight with their perfume (*above right*). You can always withdraw to the tree house and enjoy the solitude (*below left*). A place for reading (*below right*).

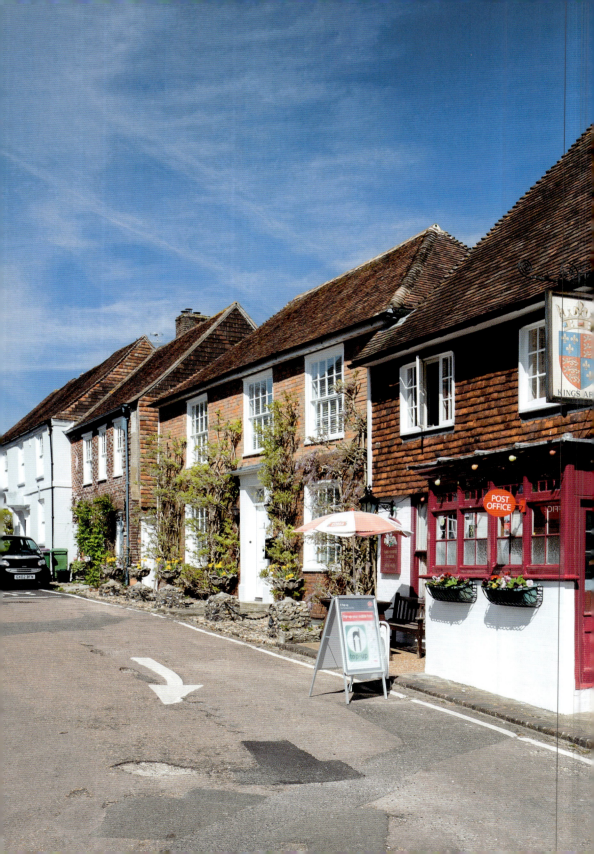

Elham, situated in Kent and not far away from Canterbury, has a rich history. The clocks go a little slower here. Walking past historic buildings in the village, such as the late medieval St. Mary's Church or charming Tudor buildings, you can really feel as if you've gone back to Tudor times. A comfortable stroll through the vineyards of the area leads you past 1,500 vines. On the way, you can of course try a glass, or you can enjoy a cup of tea in one of the cozy tearooms. In the evening you can cook your supper on the grill. Celebrate being alone as a date with yourself. You will see that if you take your own society not as a lack, but as something very precious, then being on your own can actually be great fun.

INSIGHTS:

Elham is a twenty-five-minute drive from Canterbury. The tree house can be booked all year. Heating and double glazing mean that it is always comfortable, ideal for winter and summer alike.

Prices: 🛏
https://elhamtreehouse.com/

On a walk through Elham you can breathe the air of the past.

Fforest

Japanese Scandinavian solitude in Wales

Sometimes you have to travel to the end of the world to discover that you have everything you need. This was the experience of Sian, James, and their four children, who discovered in New Zealand that their hearts actually were in the place where they spent all of their summers as children: a village in the west of Wales where the grandparents lived. Their dream took more and more shape: to live a simple life in the luxury of nature. From this realization, a charming place called Fforest was slowly born, a refuge on the coast of Wales, only minutes away from the beaches of Cardigan Bay. The heart of Fforest is the farm. Situated between sensational Teifi gorge and the nature reserve Teifi Marshes, it consists of a lovingly refurbished eighteenth-century farmhouse and a converted pigsty in Scandi-style. Between these there are artfully done glamping options that really show that the owners are art school graduates. High-quality craftsmanship and anSeye for detail provide a lot of *hygge*. When you arrive you will be greeted in the lodge. Right next to the lodge there is the Bwthyn, a sweet, tiny pub that belongs to Fforest. The most impressive, most relaxing, and most luxurious accommodations are the Onsen domes, with a cedar pool and bathhouse in Japanese style. The regular domes are probably the most-romantic places in the Fforest. They offer tons of private space and wonderful panoramic views from their windows. In the evening the two of you can snuggle up under a blanket in front of the open fireplace and listen to the crackling of the fire. The Kata Cabins are particularly generous huts, with room for five people. If you are looking for a more authentic camping experience, this is offered by the bell tents. No matter which accommodation you choose, here you can get really close to nature without waking up in the morning with a bad back or clammy blankets.

Enveloped by nature, it is easy to let go of stress (*above left*). With love for details and nature (*above right*). Your temporary home: the Onsen dome (*below*).

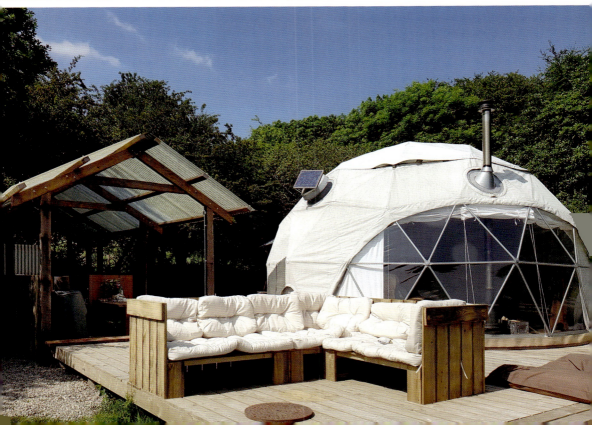

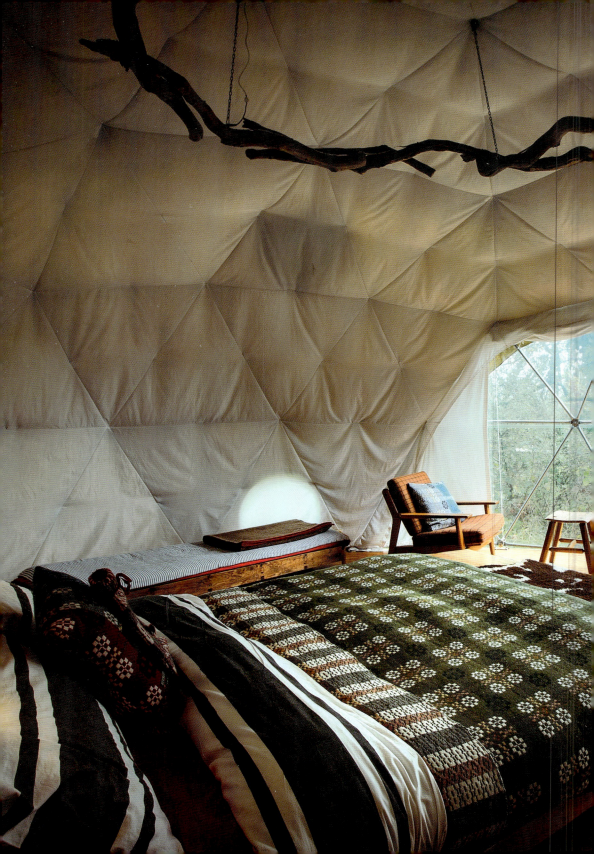

More accommodations are situated ten minutes away in a converted storage building by the river in Cardigan, and in Manorafon, a coastal camp that promises even more solitude. Everybody will find their perfect place to withdraw here.

At the Fforest you can pass your time by taking a good long nap in front of the wood burner, sweating it all off in the sauna, or gazing at the sky from the porch. But you can also sit in the adorable pub Bwthyn and drink a pint of Welsh beer, or enjoy delicious food in the lodge. Those who need more action can visit the beaches and discover the coastline on long walks. The west of Wales is also a fantastic spot for climbers, with routes for beginners and professionals alike. Surfers can throw themselves into the waves of the Atlantic Ocean. Or you could go coasteering—jumping, climbing, sliding, and swimming along the shore. Adrenalin rush guaranteed!

INSIGHTS:

The farm is only a few minutes away from Cardigan. There is a minimum stay of three nights on weekends and four nights during the week. Outside school vacation times, it may be possible to book for two nights only. The Fforest is fifty minutes by train from Carmarthen and fifty minutes from Aberystwyth.

Prices: 🛢

https://www.coldatnight.co.uk/

A successful union: stylish interior, a comfortable bed, and a fabulous view

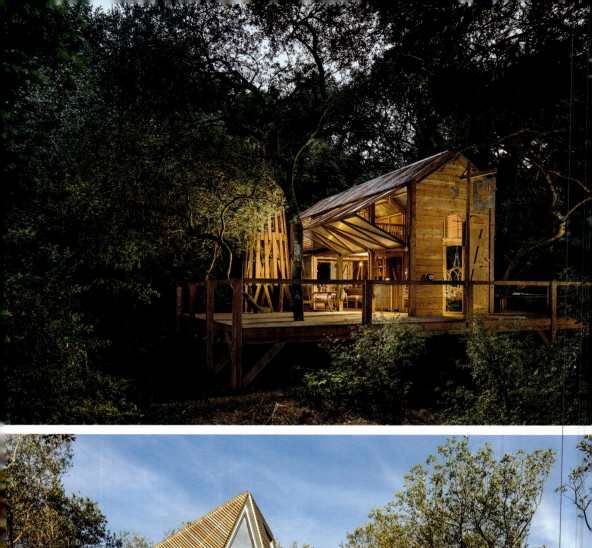
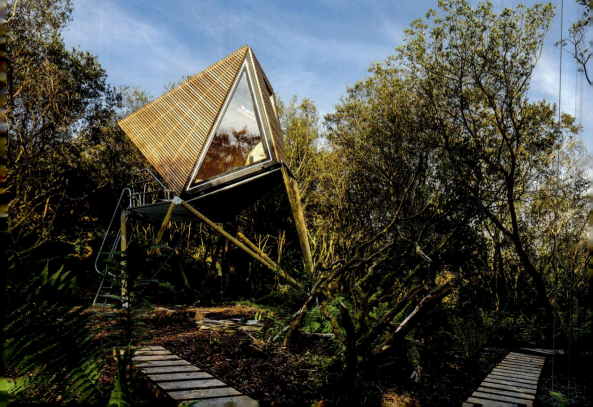

Kudhva

Once a Quarry, Today a Relaxing Hideout

The engine house on the horizon is proof that slate was quarried here toward the end of the nineteenth century. The quarry has been closed for many years, but at the time it dominated this entire northern part of Cornwall. Open mining provided work and economic prosperity. Where the quarry once was, there is now a lake fed by a waterfall.

The Kudhva composes about 45 hectares of the former quarry. Among willows and gorse bushes, wildflowers now grow in abundance. The slate pokes out of the grass and forms a contrast to the sea, whose waves break at the rocks. In this landscape, slate, grassland, forest, and sand blend with each other. You are right in the center of a rough landscape that appears to be hovering above the waves like an island. Its remoteness makes Kudhva a refuge. In Cornish, *kudhva* means "hiding place." The extraordinary glamping huts provide you with a place to hide and the chance to renounce everything, albeit for a short time. It is a hiding

This is how stylish a hut in the forest can be (*above*). The extravagant tree houses in the forest are worth seeing.

place from our overloaded, digitally burdened lives, an opportunity to listen to the waves. No duties, no deadlines, just being here. The idea behind the huts is that as temporary structures they should have no direct impact on the environment. They are in between the flora and fauna, nearly invisible by blending into the background. Built from sustainable and natural materials, the wooden huts have clear lines to give more expression to the wilderness around them. Built on high wooden stilts, you are quite far above the earth in your hut. A feeling of weightlessness takes over. There are four completely self-contained kudhva, each with a large porch outside and a sofa from which you can enjoy the views toward the sea through the windows, which cover the entire space from floor to ceiling. The bed is on a separate level. In the evenings there are campfires under a clear sky full of stars. Looking up into the sky is well rewarded at night. Kudhva is at the tip of a valley, around which there is hardly any light pollution disturbing the night sky. The perfect conditions for extensive stargazing.

Those who would like even more outdoor feeling can spend the night in the suspension tent. Suspended between trees at several feet above the ground, you can spend a night that is truly special. You feel as if you are sleeping in the wilderness, with no barrier between you and the wild. At the same time, the tent gives you a feeling of safety and security. The tiniest sound seems amplified, and this makes for a meaningful experience of nature at night. You can hear the rustling of the leaves when an animal moves, as well as the pounding of the waves. With a coastline of 292 mi. (470 km), Cornwall is definitely not lacking in fantastic beaches and coves. Your days will be filled with exploring the remote rocky coves and golden beaches, or with hiking a part of the South West Coast Path. And for all mermaids: the coast of Cornwall is a paradise for water sports.

INSIGHTS:

Kudhva is best approached by car. There is not much of a public transport network in the area. Kudhva is open for guests for only twenty-eight days of the year.

Prices: 🪙
http://kudhva.com/

The old engine house at the former quarry "Prince of Wales" now stands picturesquely among the rocks and grass as a witness of bygone times.

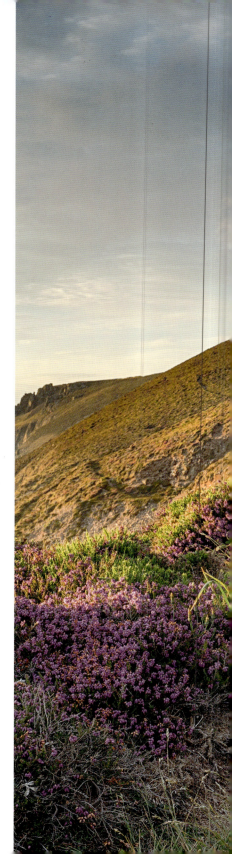

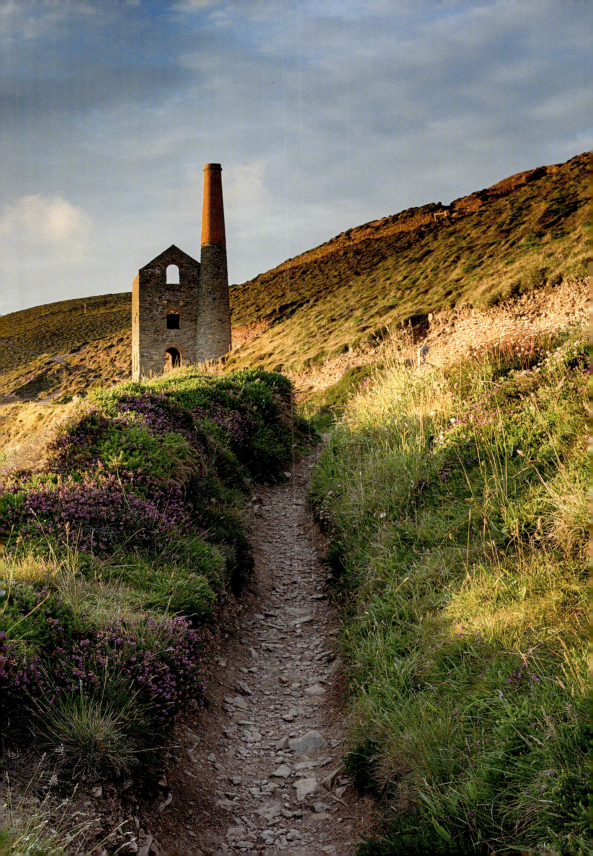

Resort Baumgeflüster

A Magic Woods in the Middle of Nowhere

Are you trying to meditate quickly at home before rushing off to work, but your thoughts are totally elsewhere? You can't switch off because there is always something to do? If this sounds familiar, some time out is worth a try! For those looking to slow down in nature, a tree house hotel deluxe is the perfect solution. The resort Baumgeflüster ("tree whisper") is a home for the soul, where you can let go of everything and find yourself again. Looking out from the tree house and into the forest, without any distractions from radio or television, is well-being of the natural kind. Here your eyes can repose completely on the trees—and your only visitors are fawns, squirrels, and perhaps even the rare goldcrest. The developed Resort Baumgeflüster was inspired by the architect of the century, Corbusier, who experimented with optimal spatial dimensions. It is situated in Bad Zwischenahn, about 18.6 mi. (30 km) from the North Sea as the crow flies. The tree houses have around 430.5 sq. ft. (40 m²) and are built among oak trees more than 100 years old. They are entirely storm secure, so nothing prevents you from feeling completely at home. Each of the four tree houses has a focus, from the local Ammerland to the Alps, Africa, and Asia. What they all have in common is that they are 100% allergy friendly. They were built from open-pored, solid wood, using neither foils nor adhesives. The untreated larch wood fills the room with its very own smell, which has an effect on the nervous system, and your heart rate slows down. You can really remain totally relaxed, even when the wind blows a bit stronger. And especially when the wind drives through the trees and the thunder rolls in the sky over the forest, it is particularly cozy inside the tree house. Because they are in a "Dark Sky Area," the tree house hotel gives you a wonderful opportunity to see the night sky as it is rarely seen nowadays. Without the city lights, the starry sky is an event. You may find yourself staying outside for hours, tucked up in a blanket and watching the sky as if it were a blockbuster movie.

Comfort and design like a hotel room—this is what the tree house deluxe offers (*above left*). The tree houses were built on the basis of designs inspired by the icon of architecture, Le Corbusier (*above right*). The birds serenade you while you have breakfast on the porch in the morning (*below*).

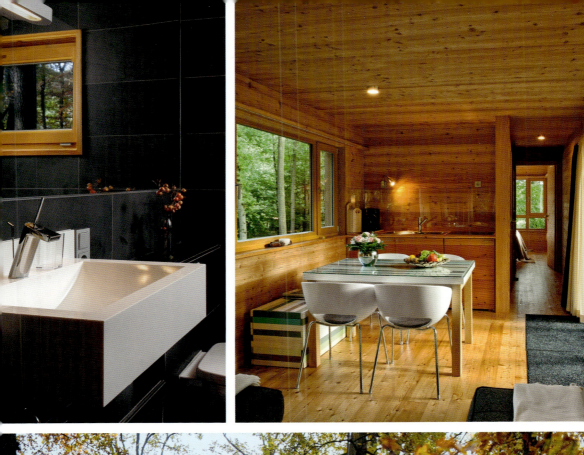
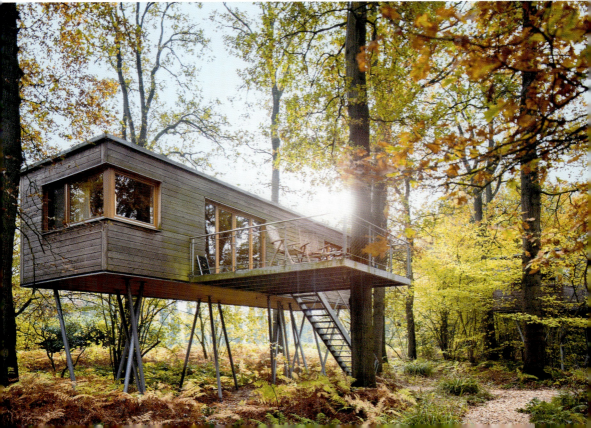

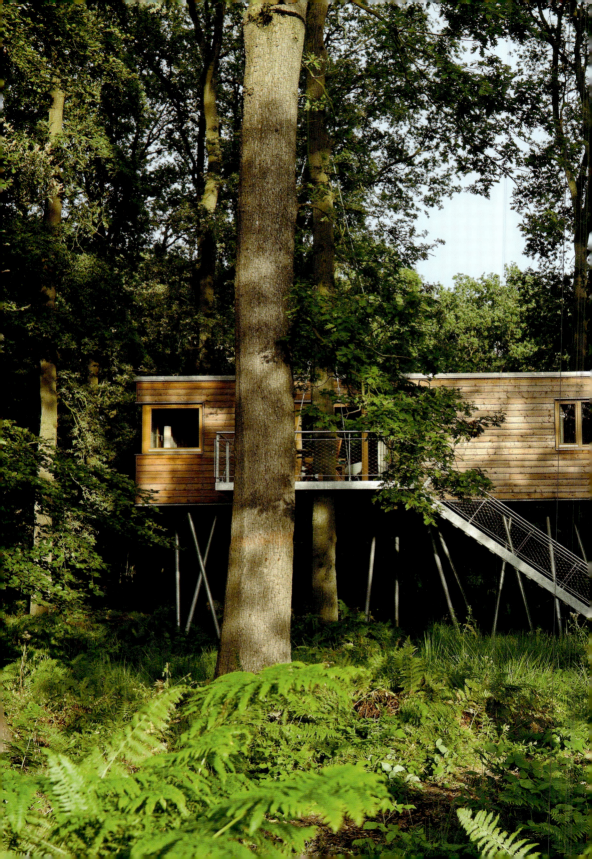

You may recognize a zodiac constellation or perhaps identify the ISS—a wonderful experience in the Hideaway Retreat, somewhere in the middle of nowhere.

New York–based magazine *Departures* has rated the Baumgeflüster among the top ten tree house resorts in the world, and when you're here you understand why. You will find yourself in the midst of the park landscape of the Ammerland and only 1.86 mi. (3 km) from the Zwischenahner Meer, a beautiful lake. Europe's perhaps most beautiful Rhododendron Park is only a ten-minute bike ride away. The parks and gardens of Bad Zwischenahn, stretching more than 167,438 sq. yards (140,000 m²), make for another great day out—it is no surprise that people call it the "Mainau of the North." The North Sea and the Zwischenahner Meer offer a variety of possibilities for water sports, such as sailing, skiing, or waterskiing, and guided walks across the mudflats. Nonwater sports include swing golf and horse riding, or a visit to the climbing forest. If you prefer things to be a bit more comfortable, you can take part in an East Frisian tea ceremony.

INSIGHTS:
Bad Zwischenahn is situated about an hour away from the sea. Bookable from one night.

Prices: 😎
https://www.baumgefluester.de/

Well-being for everyone: the tree houses are built and furnished 100% suitable for people with allergies.

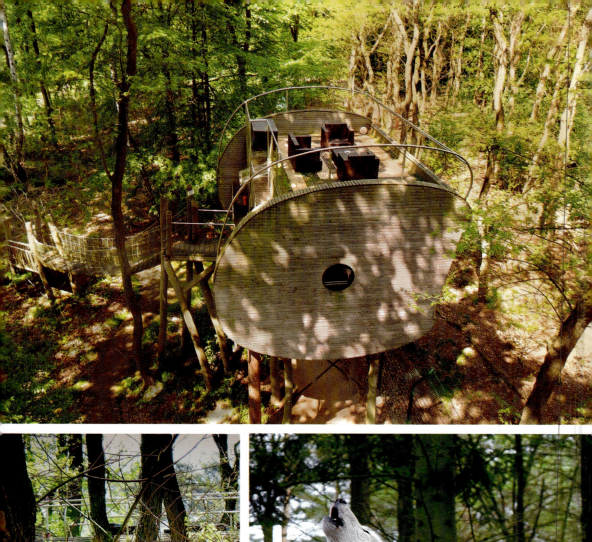

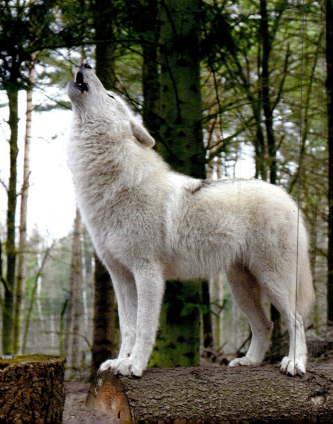

Tree Inn

A Night with the Howling of the Wolves

Wolves are fascinating animals of prey. They roam our forests as solitary individuals, hardly seen by anyone. Not so in the Wolfcenter Dörverden between Bremen and Hanover.

In the Wolfcenter Dörverden you can admire several packs of wolves up close, and what is more, in the Tree Inn you can spend the night in a tree house right above the wolves. A night among wolves sounds like a thrilling adventure, and when the wolves howl in the night, you will feel it in your bones. But the European grey wolves and white Hudson Bay wolves are reared by hand, and if you stick to the center's rules there is no need to be afraid. From your tree house you can quietly observe these mysterious animals. This is a unique experience, especially at night, when all visitors have left the wild animal park and you are all alone with the wolves.

You reach your accommodation for the night via a rope suspension bridge. The inner area comprises 323 sq. ft. (30 m^2); the most important thing is the glass front, enabling unencumbered views of the enclosure. One level up, the view is even better. Via a staircase you get to the roof terrace. Here you can settle down on comfortable plush sofas. The wolves are curious and enjoy having a look at who is living in the neighborhood. There is no reason to go to bed early, so take the supplied torches and explore the outdoor space at the Wolfcenter at night with no pressure.

But the tree houses themselves have a lot to offer. If you think the tree houses are mere provisional huts, think again. Even if the highlight of the enclosure definitely lies outside your four walls, the inside is not lacking in comforts. There are adjustable flat-screen HD screens, Wi-Fi, under-floor heating, air-conditioning, and a whirlpool. Here glamour meets outdoor adventure. For supper, you can order a picnic basket with exquisite foods, which is delivered to the tree house in the evening. In the morning the wolves are your alarm clock—hardly an everyday experience.

The roof terrace is the best place to view the wolves (*above*). A vacation in the forest with wolves that sounds like an adventure (*below left*). At night you can hear the wolves howl (*below right*).

If you want to get even closer to the wolves, you can book the Tree Adventure. Here you can join the wolves for half an hour in their enclosure. Of course a keeper is always with you. This provides you with an unparalleled opportunity to take pictures of the animals and to really experience the wolves up close. If you want to know more, you can find everything about wolves in the Wolfcenter. The calendar gives you all current tours, events, and workshops.

INSIGHTS:
There is a total of two tree houses sleeping four people each. The Tree Inn is situated 8 mi. (13 km) from Verden, 25.5 mi. (41 km) from Walsrode, and 34 mi. (55 km) from Bremen airport.

Prices:
www.tree-inn.de

The Tree Inn is doubtlessly the perfect accommodation for wolf fans.

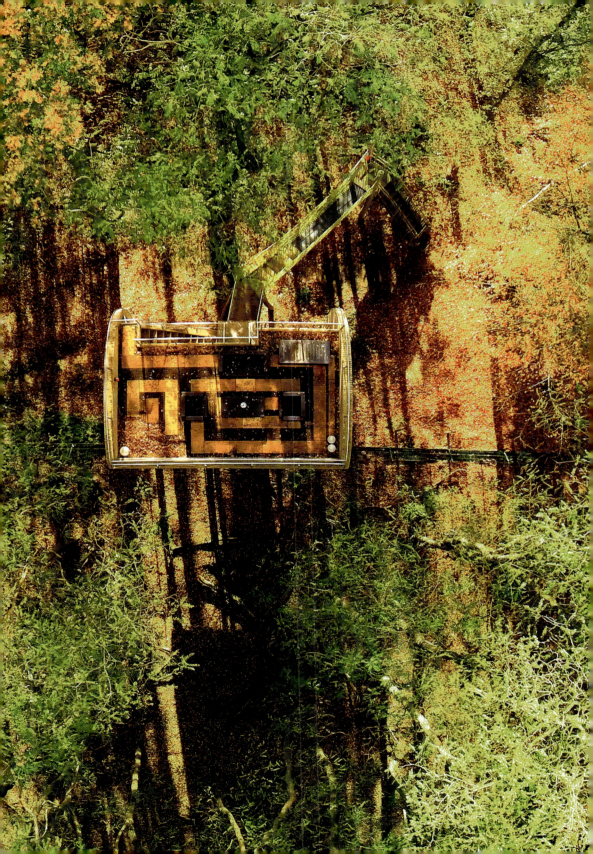

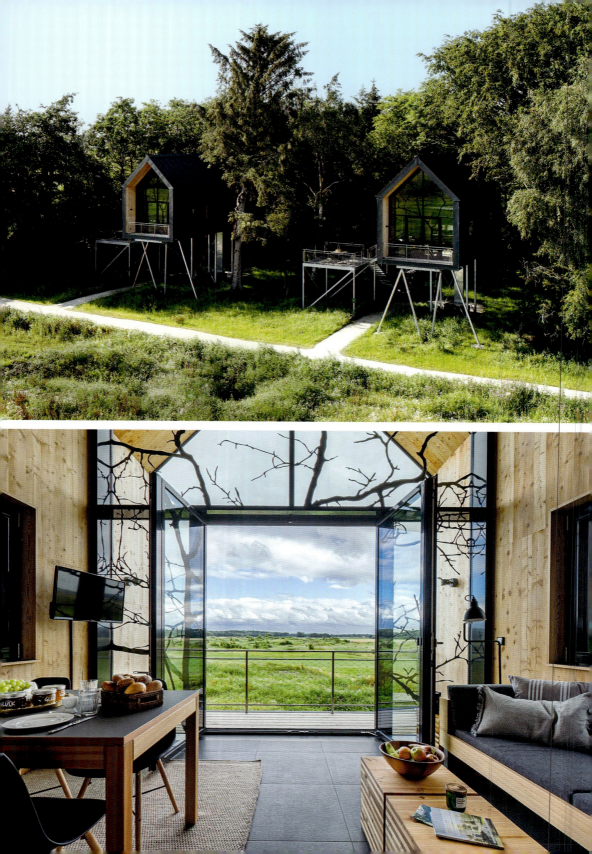

Lütetsburg Lodges

Say Good Night to Fox, Badger, and Deer

When you wake up, your eyes wander out into nature instead of the screen of your mobile phone. You can hear birdsong instead of the noise of the city. Through the windows you have a panoramic view of the open East Frisian landscape. Take a deep breath and feel good—that is the motto here. Only 8 or so miles away from the UNESCO World Natural Heritage site of the East Friesian Wadden seashore, you will find three tree houses hidden in a small woods. They are named after typical inhabitants of the forest, but in low German: Voss, Dacks, and Reei. The owner, Count Tido zu Inn-und Knyphausen, was cherishing a dream of sleeping in a tree house once in his life, or rather, building one. He has now fulfilled this dream for himself, directly on the doorstep of his estate. The carefully designed houses built from untreated wood are nearly invisible in the forest because they skillfully blend with the landscape. The glass fronts allow plenty of light to stream into the houses and, at the same time, allow an unobstructed view of the surrounding forest. Inside and outside merge. Even when you take a shower, your eyes can feast on green. The generous porch and the balcony are ideal places for relishing the peace and quiet of the morning. Whether it is with meditation, yoga, or simply a cup of coffee among the branches, your day is sure to start mindfully and peacefully here. During the day you can stretch out in a deck chair with a good book or go for a walk on the castle grounds. The nearby North Sea invites for day trips to the islands. The boat to Juist or Norderney takes only fifteen minutes. When night falls, the deer come right up close to the tree houses, foxes roam freely through the forest, and with the binoculars supplied, you don't miss a single animal on its way past.

INSIGHTS:

A tree is planted with each booking. The houses are situated on a 50-hectare estate that also includes a natural golf course. It is a ten-minute drive to the boating pier in Norddeich.

Prices: 🪙
https://luetetsburg-lodges.de/

The lodges are proof of the fact that you don't have to have sea views to have a fantastic vacation in East Frisia (*above*). From the inside of the tree house you have fabulous views of the plains (*below*).

Cloefhänger

Between Heaven and Earth

The tent swings freely above the forest floor, and directly in front of you is the sheer drop of the Saarsteilhänge (escarpments over the river Saar). Here, with the Cloefhängers you can experience something usually accessible only to experienced climbers in one exceptional night.

The viewpoint Cloef is directly at the top of the Saar Loop. From here you have a perfect view of the famous bend that the river Saar makes here near Mettlach. The landscape is dominated by mixed forest. The nature reserve Saar-Hunsrück offers a unique landscape experience both natural and cultivated, with the river Saar, vineyards, and extensive forest areas. Your very special adventure starts in a parking lot. From here a guide will take you the last 328 yards (300 m) to the camp on foot. The path goes continuously uphill—which isn't a surprise, if you consider the goal is one of the most famous viewpoints in Germany. Following a short safety induction, you will help the professionals hitch your sleeping place for the night among the trees at 6 to 10 ft. (2 to 3 m) above the forest floor. At nightfall the unparalleled view will impress you. A campfire is lit when darkness has descended on the river. The perfect backdrop for getting to know each other, sharing stories, and eating together. When the first among you starts yawning, it is time to go to bed, or rather, into the suspension tent. You climb up via a rope ladder. At first it will shake a little bit, but once you have settled down, only a pleasant sensation of being suspended in the air remains. Here, in the middle of the forest, the air at night feels very different, much more intense. The fresh air makes you nicely tired, and the stars in the sky seem to be close enough to touch. Then the gently swaying tent will rock you to sleep. The next morning the Saar Loop will greet you with another perfect view. Mist rises from the valley, the sun slowly peeps out from among the clouds, and the surface of the river starts to sparkle and glisten. This picture will burn itself into your memory because it is so extraordinarily beautiful.

Rather spectacular: the view across the Saar Loop (*above*). Take courage and you will be flooded by endorphins (*below*).

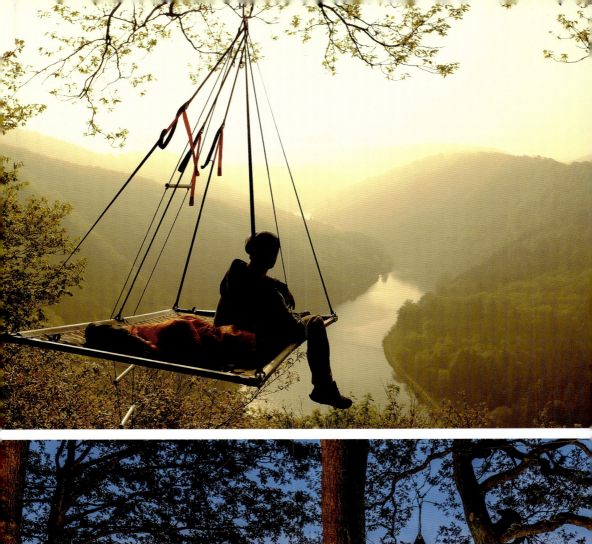
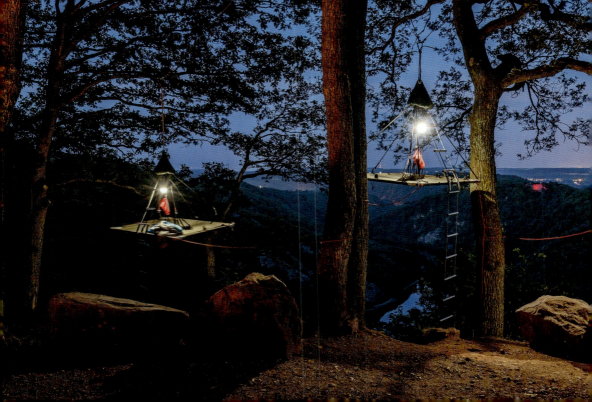

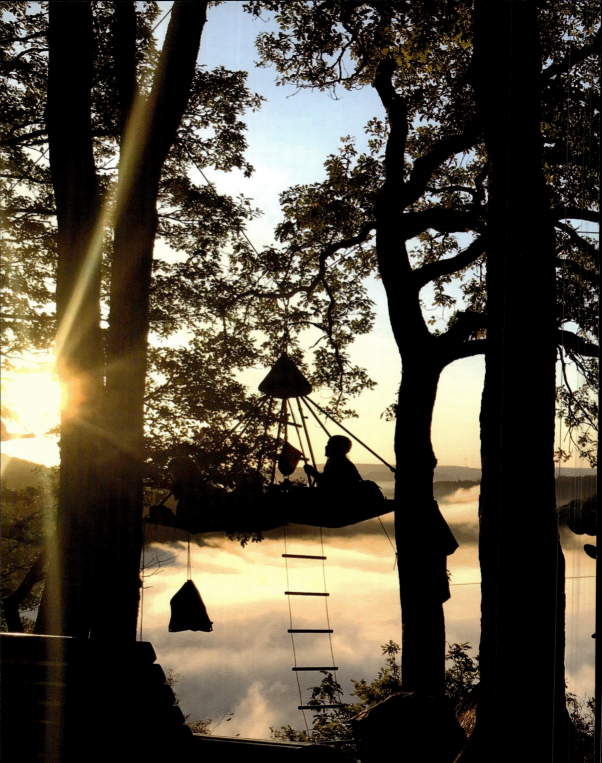

Martin Hager had the idea for these unusual opportunities to spend a night. A passionate globetrotter and outdoor enthusiast, he felt inspired to bring some of these outdoor adventures home. He wanted to create an opportunity for the very special experience of spending the night in a suspended tent in a place with a spectacular view, and he wanted this opportunity to be available to people right where he lived. This is how the Cloefhänger was born. When your night in the suspension tent is over, your Saar Loop adventure can continue. There are numerous trails through the nature reserve, and those who have been bitten by the Alpine bug can explore the nearby treetop walk.

INSIGHTS:

The Cloefhänger is open every Saturday between July and September for overnight stays. The number of participants is limited to four to ten. You meet at the parking lot in Cloefstrasse in Orscholz.

Prices: 🪙
https://www.cloefhaenger.com/

A once-in-a-lifetime experience: the sun is rising in the morning, and the mist is floating through the valley.

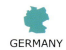
Moselglamping

A Night with Views over the Mosel River

A tiny glimmer, then another, and suddenly the air is full of tiny glowing dots—glowworms rising from the grass at dusk. A magic picture with the river Mosel in the background.

Glamping accommodations are more commonly found in places of unspoiled natural beauty, but in the case of Moselglamping, the journey goes right into the heart of the Mosel town of Traben-Trarbach. But don't worry; there is no trace of everyday rush and noise here! Directly on the banks of the river Mosel, surrounded by vines and in a picturesque wine-growing town complete with a castle ruin, things are very quiet here. In an enchanted garden of a villa 160 years old, you will find a magically beautiful safari tent with views over the river. An exclusive location with lots of privacy and luxurious comforts. From the first glance you will know that the owners, Carol and Julian, have poured a lot of love into this place. Moselglamping is the project

closest to their hearts. As an all-round craftsman, Julian has built the camp predominantly from preused materials that have their own story. This is particularly obvious in the Open-Air bath, nestled between the tent and a wall completely overgrown with ivy. An old enamel bathtub from the 1890s was reused here. The lid of a wine keg on pebbles from the river was turned into the shower pan, and hand-soldered faucets and copper tubes were integrated into the bathroom. Nothing is accidental here. Even as a child, Julian loved spending the night outdoors in a tent. He built tree houses, and with this place he fulfilled his own dream of a perfect hideaway. Carol teaches yoga and meditation and runs a small pottery studio in the house. Guests can, if they so wish, take part in a yoga class, try their hand at pottery, or practice qigong with Julian. Carol originally trained as a gourmet chef and can cook special culinary delica-

Sitting on the chairs and enjoying the views of the river Mosel (*above*). Nestled between ancient vinery houses is the safari tent (*below*).

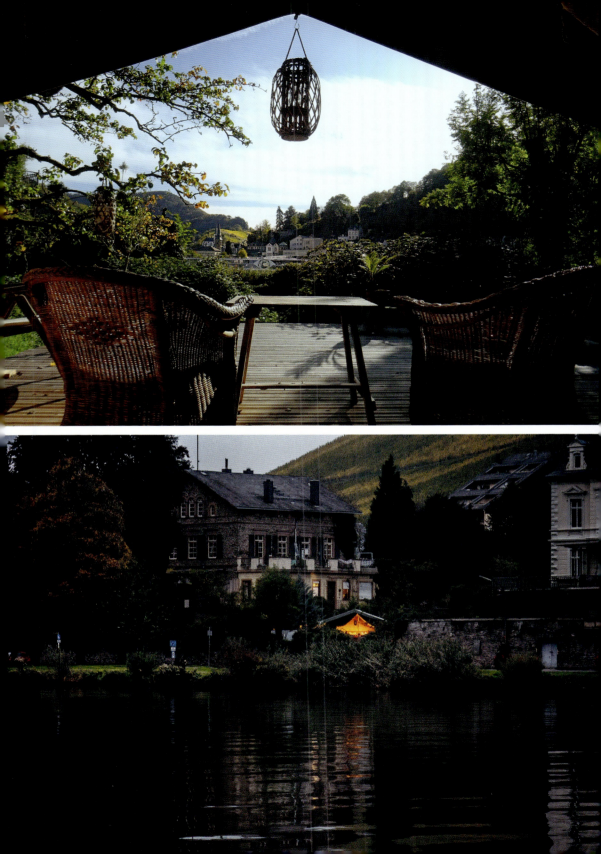

cies for guests if they like. You can also book tours to visit the gems of the area, including secret locations. The program includes snorkeling in the Eifel Maar, and with a bit of luck you can see pike or carp. A tour through the vineyards, including tasting sessions, is of course a must here on the Mosel. With a glass of wine in your hand and views over the river Mosel and vineyards, you will understand the way of life of the Palatinate region.

INSIGHTS:
The Moselglamping is on the outskirts of Traben-Trarbach on the river Mosel, easy to reach by train from Koblenz.

Prices: 🪙
https://moselglamping.jimdofree.com/

Vintage, safari, and a lot of comfort is what you will find in the safari tents.

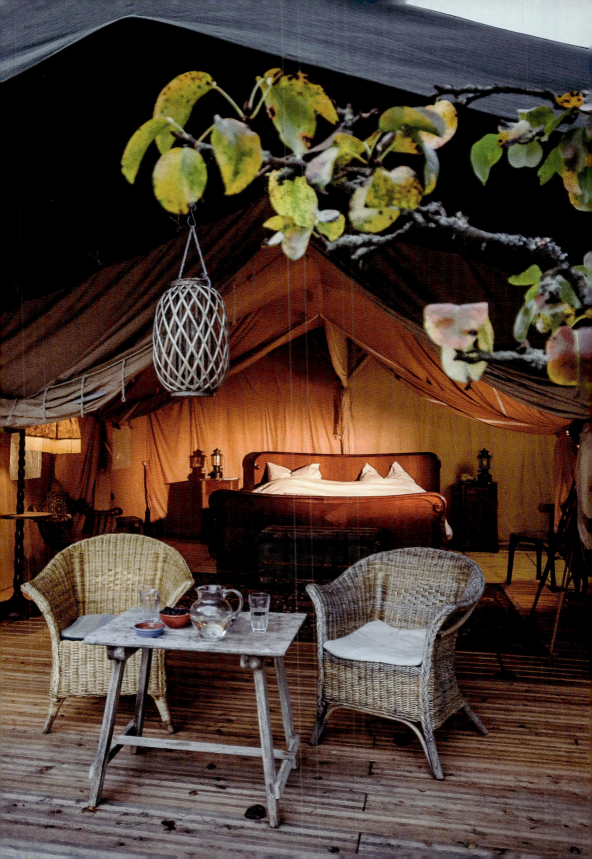

Attrap'Rêves

Hideaway for Romantics

Attrap'Rêves means "dream catcher," and there couldn't be a more suitable name for this magical place. There is no chance of bad dreams here, guaranteed!

But not only is this special hideaway in Provence a place to enjoy beautiful dreams at night, it is also a place where dreams come true. Is there anything more romantic than withdrawing with your favorite person into a magic space where there is nothing to obstruct the views into the landscape? The starry skies, hares, birds—here you dive completely into an environment that couldn't be more peaceful. The Attrap'Rêves is a refuge situated near Allauch in Provence. The air smells special here, of lavender, lemons, and rosemary. It is no surprise that Provence is the center of perfume crafting. Here, at the Attrap'Rêves, nestled among this landscape that is so full of character, everything is about a romantic experience: from bubble massages, to three-course dinners delivered directly to your door, to champagne and a bath in the hot tub. A place to celebrate special occasions. "Special moments"

are at the core of this family business, and this means your stay is going to be a guaranteed success—and sometimes you don't even need a special occasion for a romantic time out together; perhaps you can go for this joint retreat "just because."

The bubbles or domes—whatever you want to call these transparent accommodations—are situated in a large field framed by a huge pine forest. Remoteness is not an issue. For your special time for two, you can choose between three different types of bubbles. In contrast to the entirely transparent Zen-bubble or Love-nature-bubble, the Glamour-bubble and the 1001-bubble are partially shaded. In this way there is enough privacy and yet there is enough space to utterly adore the night sky. To facilitate the latter, there are telescopes in the bubbles. Using a star map, you can identify the details of the firmament. It is a priceless experience to see the Milky Way so clearly.

Nearly invisible: in the bubbles you sleep under the open sky (*above*). The transparent dome tents are situated in a large field to ensure privacy (*below*).

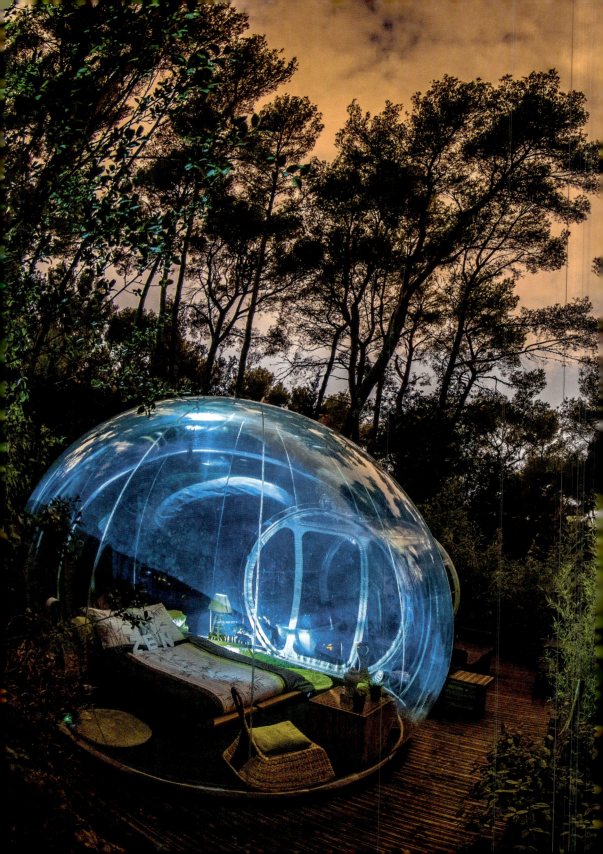

During the day you can explore Provence. On a walk to Allauch village, you come across a beautiful view of the whole of Marseille, including the famous Notre Dame de la Garde. Equally romantic is the historic town of Aix-en-Provence. Here you stroll through ancient streets, past charming stone houses complete with sweet-smelling flowers at every corner and humming bumblebees. Whatever your reason to visit the Attrap'Rêves, you can be sure of an unforgettable time. The landscape of Provence, the stars in the sky, and lots of time for just the two of you are a foolproof recipe for what will probably be the most romantic getaway of your lives.

INSIGHTS:

Private showers, toilets, and parking are available. Fifteen minutes from Marseille, thirty minutes from Aix-en-Provence.

Prices:
https://www.attrap-reves.com/

There is always something to admire: in the morning the bird song, at night the stars.

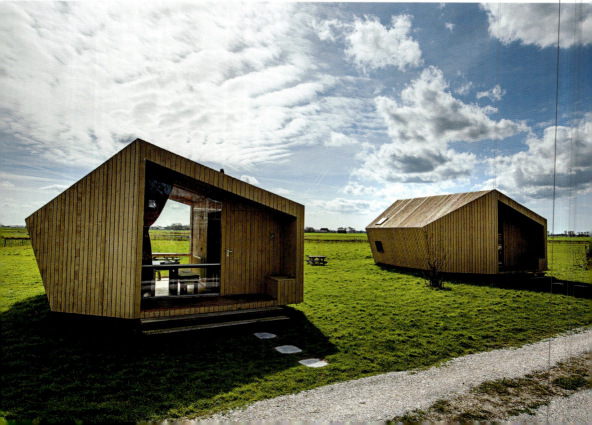

It Dreamlân

The Sunny Side of Camping

You feel like an outdoor vacation, preferably in the middle of a meadow where you can hear the mooing of the neighborhood cows. But you don't feel like sleeping on the hard ground, you don't like hot tent air (which doesn't let you sleep in the morning), and you like using shared showers even less? You simply need a little bit more comfort than a tent usually offers? Then the It Dreamlân simply offers the best compromise among lots of comfort, the camping feeling, and those particular amenities that allow you to sleep well. On this unconventional camping site, you find comfortable Trek-In huts, which are the perfect combination of being close to nature and a feeling of security. A lot of heart and soul have gone into the creation of this place. You can sleep on a comfortable mattress, and you have your own shower and toilet and even a small kitchen with a fridge to make your own meals. This is camping totally without the irritating need to haul tons of luggage and with a lot of useful extras. Sounds good, doesn't it? Once you have woken up with the sun in the morning to admire the breathtaking view through the large windowpanes across the expanse of the Frisian pastures, you will never want a different type of vacation again. That this accommodation is inspired by principles of sustainability makes it even better. The camping huts are built entirely from recycled materials, following the cradle-to-cradle idea. No matter what time of the year, whether alone, with your favorite person, or with your entire family, there is one thing that you must not miss during your vacation in this place between the provinces of Groningen and Frisia: a walk through the Wadden Sea UNESCO World Heritage site. When you want to take a step forward but your foot is stuck and your legs are black with mud right up to your knees, your inner child will rejoice.

INSIGHTS:

The It Dreamlân is between Leeuwarden and Groningen. It offers accommodation and a camping site with different options to spend the night. It was built with a lot of love and is maintained as a family business.

Prices: 💲
https://www.itdreamlan.nl/

Your only neighbors are the cows (*above left*). Let off steam on a paddling tour while letting nature pass by (*above right*). Entirely without putting up and taking down—this is how we like camping (*below*).

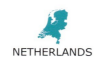

De Vreemde Vogel

From Nesting Box to Airplane

A vacation on a farm with goats, sheep, and chickens always feels a bit like summer vacation when you were a little child. And that alone is enough to make us happy. But De Vreemde Vogel has so much more in its back pocket! On a hill and surrounded by forests and moorland on the edges of the Midden-Delfland nature reserve, this outdoor hotel is unlike any other. There is a small river that cuts through the meadow, where rowing boats wait to be taken on a tour, a playground, and a garden café. So far, so good, but the best really are the accommodations: on the grounds of the De Vreemde Vogel there are the craziest places to spend a night. Sleeping in a safari tent is one of the more "ordinary" ways to sleep here. It gets a bit more unusual in a nesting box, or in a vintage caravan on stilts at an airy height. Or perhaps you fancy a real airplane that can be steered with a video game console, a bird's nest, a parrot wagon, a moon rocket, or a fire engine? For children, it is as if all their wildest dreams come true in this outdoor hotel in proximity to the city of Delft, but even adults will succumb to the charm of these imaginative houses. All this was conceived by the Knijnenburg family, who have converted this former camping site into a wonderland since 2013, using all their creativity and a good dose of humor. There is even an escape game on-site. You will have noticed that everything is a bit different here, and in the restaurant it may well be that your dinner arrives in a birdcage.

INSIGHTS:

The accommodations can be booked all year. You can also book the entire site for special occasions and events. An outdoor kitchen is available. Only a stone's throw from Delft and Rotterdam, De Vreemde Vogel is easy to get to.

Prices: 🪙
https://www.devreemdevogel.nl/

Have a good rest in a bird house (*above left*). A vintage caravan as a tree house (*above right*). Vacation vibes in the iron bird (*below*).

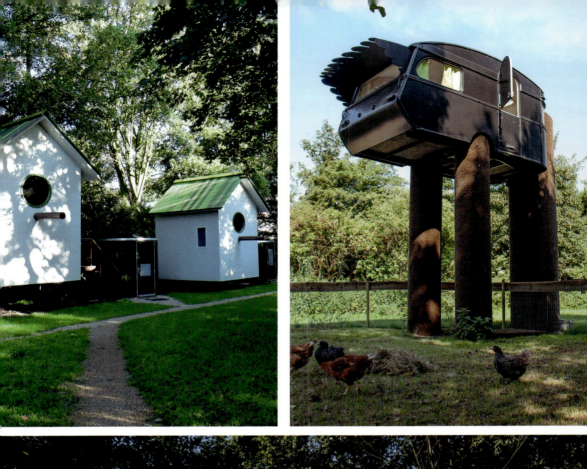
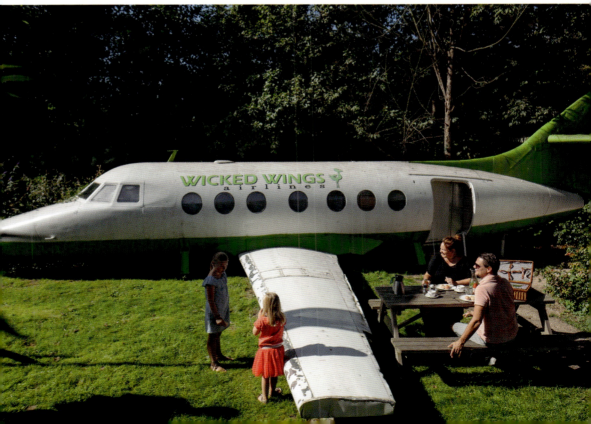

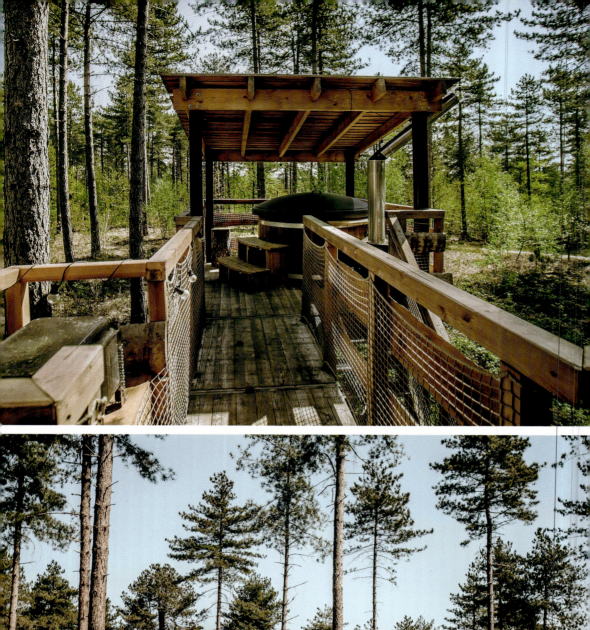

Warredal

A Nature Hideaway Not Only for Horse Fans

If you love horses, you will fall in love with this place: the riding center Warredal is one of the biggest in Belgium. Situated in proximity to the borders with Germany and the Netherlands, it is not only horse fanatics who will get their money's worth during a vacation here.

When the place was completely refurbished in 2018, thirty-two huts for nature lovers were created, all according to the maxim "Less is more." The focus is entirely on peace and quiet, and an experience of the environment. Simplicity is celebrated without much ado. Sustainable parts, eco-friendly materials, and handmade furniture were chosen for the huts. Each hut has an area for lounging

INSIGHTS:

Warredal is situated in Neeroeteren, which is part of Maaseik. It is easy to reach from Belgium, the Netherlands, and Germany by car. From Brussels it is an hour's drive, one and a half hours from Cologne. If you prefer to arrive by train, the nearest station is Genk. From there, take the bus to Maaseik.

Prices: 💲
https://warredal.be/

and eating, a heated bathroom with a shower, a small kitchen, and a porch. Some of the cabins even have a hot tub. Back to nature, that means no Wi-Fi and no television here; instead you will find a much-better connection here—a connection with nature. The entire grounds are a 24-hectare park in the Belgian region of Limburg, close to Hoge Kempen National Park and the Bergerven nature reserve. It goes without saying that the best and most authentic way to explore the area is on horseback. To the beat of hooves, the beauty of nature will have its effect on you, and your energies will be recharged effortlessly. On the back of a horse, your everyday worries will simply evaporate. If you crave more adrenaline, go whooshing through the forest on the zip line. The little ones will love the gnome golf. Well-hidden gems in and around Limburg are easily explored in the area on extensive walks and day trips into the nearby Hoge Kempen and Bergerven National Parks.

Feeling like spa treatments? Round off the evening relaxed (*above*). The accommodations: unassuming and with a focus on the essentials (*below*).

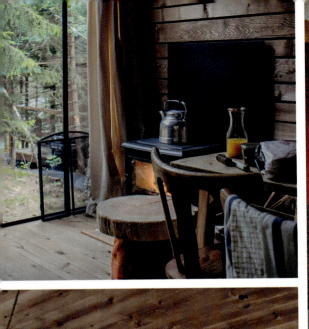

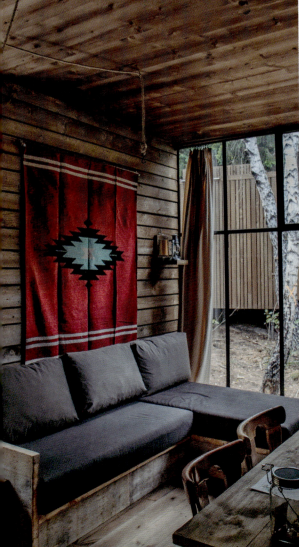
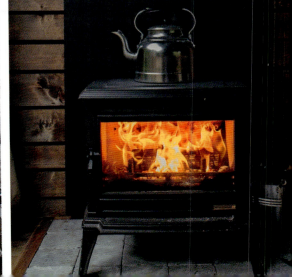

Nutchel Forest Camp Les Ardennes

Between Forest Bathing and Microadventures

The picturesque hills of Martelange, a beautiful, luscious, and green region in the heart of the Belgian Ardennes mountains, are the ideal place for spending a few days in perfect harmony with nature—and for going on microadventures with friends and family.

As soon as you have crossed the bridge over the river Sûre, it is only a small distance to the Chalets, the heart of the Nutchel. You will be welcomed here, and it is here that you can sit by the open fireplace and enjoy a hot chocolate or sit with other guests around the campfire in the evening. From here you proceed to the pretty forest huts. There are twenty-six cozy tiny houses nestled into the landscape in the most idyllic way imaginable. Within a steel frame, wood, and large windows hides a cozy interior. The windows allow a first-class view of the woods. Each house has a kitchen, comfortable beds, and a bathroom. In the evening you can sit by candlelight—it couldn't be more snug!

In the Nutchel the premise is that nature is a playground. Children can let their imagination run wild, create memories, and make discoveries. Forest bathing, called *shinrin-yoku* in Japan, has arrived here too. This therapeutic practice helps you bond with nature. If that isn't your thing, or not enough, a yoga class or a visit to the sauna guarantee happy days.

The right place for a cozy breakfast (*above left*). Quality time with your loved ones (*above right*). Small is beautiful (*below left*). Fancy a cup of tea (*below right*)?

With plenty of hiking and biking trails, there are a range of opportunities to explore the area actively, especially with the Haute Sûre Forêt d'Anlier nature reserve on the doorstep. The gently rolling hills invite hiking and mountain biking. Lac de la Haute Sûre is a gorgeous lake that is a mere twenty-minute drive away from the accommodation and is suitable for picnics and water adventures. Canoeing, kayaking, and even snorkeling are possible here.

INSIGHTS:

The Nutchel is close to Martelange, in the Belgian Ardennes, a stone's throw from Luxembourg. You can book either a weekend break from Friday to Sunday or from Monday to Friday. During the off-season, you can also book two or three nights during the week.

Prices: 🪙
https://www.nutchel.be/

In unison with nature: this is glamping in the forest!

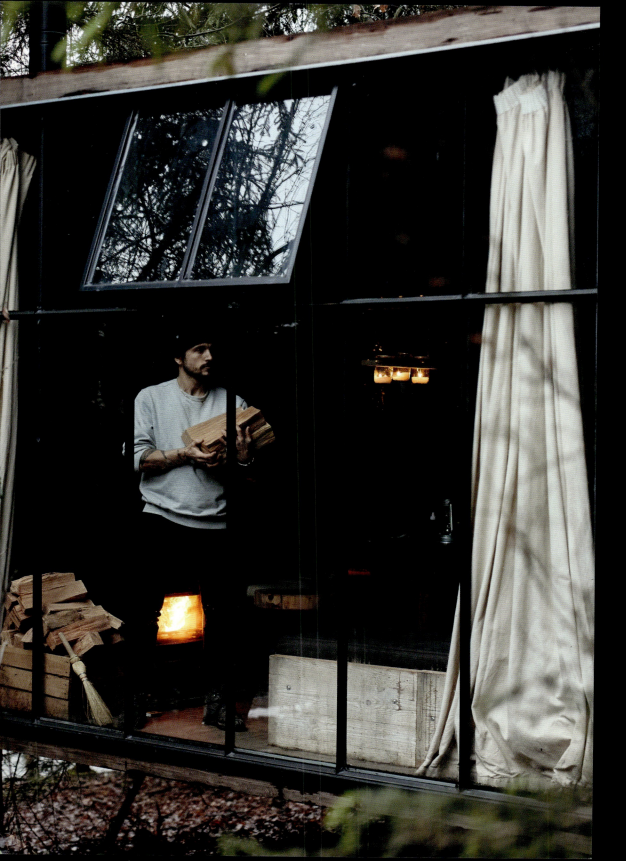

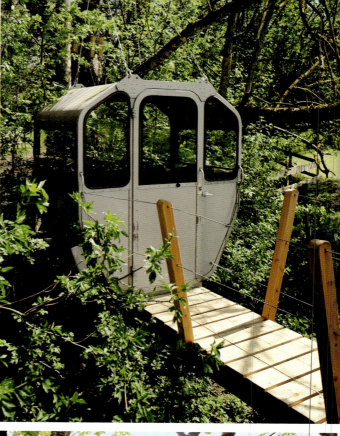
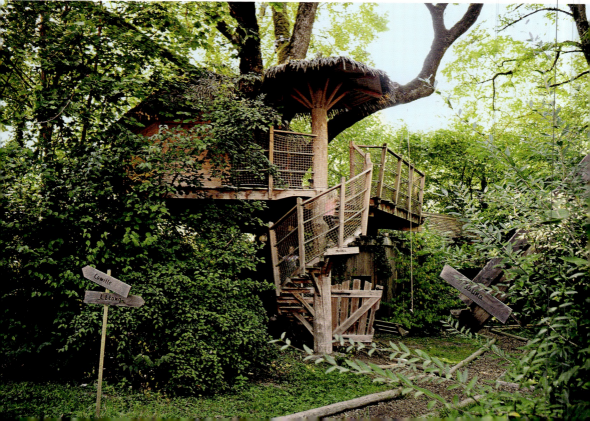

Les Cabanes de Marie

Well-Being in Switzerland

Ticking off sights on a tight daily schedule—we came here to see things, after all! Sometimes a vacation resembles a marathon more than anything else. But in this way, a vacation has little to do with relaxation. In Les Cabanes de Marie in Switzerland, things are very different.

Here, in the hinterland of Lausanne, you can spend a vacation of an unusual sort. Far from everyday life and the big city, you will find three tree houses and a caravan tucked away near a rushing river. The only thing you have to do here is enjoy the peace and quiet, whatever the weather. But don't worry; it does not get boring. The Goumoëns family had enough of stressful jobs and frequent relocations. They decided to turn their focus back to the essentials: spending time together as a family, being outdoors, keeping animals, and building tree houses. Now their guests enjoy the benefits of their decision. The cozy accommodations are named after the children of the family. The temple Camille is furnished with art and furniture from Asia. The tree house Mathis is particularly snug, with a northern-type hot tub, a sauna, dream catchers, and fur blankets. The little farmstead Alanis offers the best views over the grazing horses and pecking hens. The construction trailer Mila is a veritable kingdom full of surprises; it was designed by interior designer Jorge Cañete. This is a place where you can totally live in the moment, but if you need something to enrich your day, you can ride the ponies or follow the educational forest trail. Your evening program could include a massage or a bath in the wood-fired hot tub. Who really wants to go sightseeing?

INSIGHTS:

All houses are well insulated and can be heated. Les Cabanes de Marie are near Lac de Neuchatel, only 16.7 mi. (27 km) from Lausanne, 31 mi. (50 km) from Fribourg, and 45 mi. (73 km) from Berne. The nearest train station is Lausanne; from there it takes about an hour by public transport to Ogens.

Prices: 🥞
https://www.lescabanesdemarie.com/

Even in the winter it is definitely a cozy place (*above left*). There is something new to be discovered on every corner (*above right*). The architecture is at one with nature (*below*).

Les Ormes

Leaving All Worries behind in Brittany

We tend to think of club vacations and glamping as mutually exclusive, but Les Ormes in Brittany succeeds in combining no-worries packages with individually designed family vacations.

Where in the Middle Ages the bishops of Dol resided in a small castle, there is now a camping site, and one of the most beautiful ones in the entire country. Les Ormes has succeeded in finding a pleasant balance. Here you can get the entire comforts of a club hotel, the proximity with nature you'd expect from camping, and the luxury of gorgeous accommodations. It would go beyond the scope of this book to list the entire range of services and activities, but a few of them have to be listed. There are pools, a children's club, restaurants and bars, an aqua park, a spa area, an eighteen-hole golf course, a mini-golf range, various sports courts, a paintball field, a climbing wall, pedal boats, and lots more. But if you now ask yourself where in all this you will still feel close to nature, you will be comforted immediately when you see the glamping accommodations spread out across the estate. There are so many to choose from that making a decision is rather difficult. Beyond the camping pitches, normal hotel rooms, and vacation rentals there is the Camping'Hutte, a kind of hut on stilts between the trees; there are also tree houses, wine kegs for two or four people, and a Russian dacha. If you are looking for a romantic getaway, there are the "bubbles," tree domes that guarantee an undisturbed time with your partner. But hands down our favorite accommodations are the water huts. These raft houses are created in small ponds at the heart of the estate. Depending on how much water there is in the pond, you can move the raft with a large rudder slowly across the water.

Access to the family tree house, one of the most beautiful glamping accommodations in Les Ormes, is via a spiral stair (*above*). In terms of comfort, the tree house is not deficient compared with a vacation rental (*below*).

INSIGHTS:

Les Ormes is on a 200-hectare estate in Epiniac, near Dol de Bretagne. The town is ideally connected with Saint Malo and Mont St. Michel.

Prices: ⊙

https://www.lesormes.com/

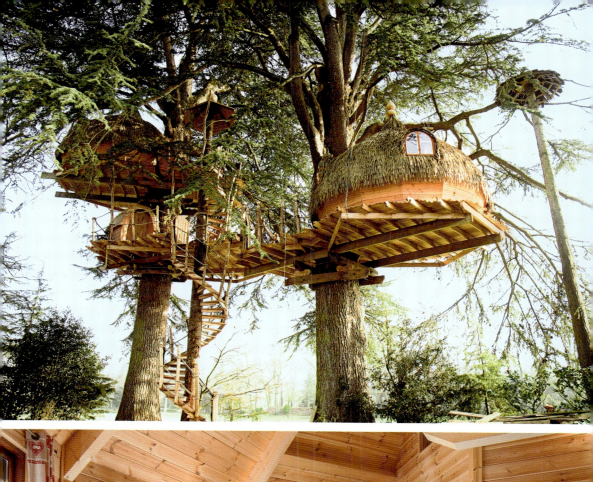
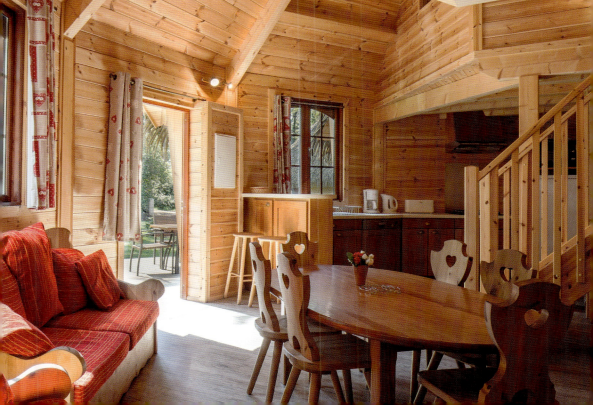

South

ITALY

Vedetta Lodges by BeVedetta

Open-Air Vacation with Luxury Suites in Tuscany

Immediately after waking up, you are faced with the decision whether to cast your eyes first over the medieval town of Scarlino and the valley below Gavorrano, or perhaps rather over the sea, where the islands Elba and Corsica rise above the blue. These are the kind of choices the Vedetta Lodges offer, and how you decide is eventually a matter of personal taste.

On the southeastern ridge of Poggio La Forcola, the tents blur into the landscape. Surrounded by olive trees and hills painted green by the meadows, and the sky a blue expanse stretching overhead, these tents are a generous 538 sq. ft. (50 m²) large, offering enough space to feel comfortable. They are named after the Pleiades, with each lodge containing a large bed, an en suite bathroom, air-conditioning, and heating. Entertainment, too, is not economized. There is a large HD television screen as well as Wi-Fi. The lodges are an idyllic retreat for doing nothing, and at the same time the perfect point of departure for discoveries into the surrounding areas. True luxury is the coastline of the Maremma, 124 mi. (200 km) in total. In the north, the Gulf of Baratti, with its dark, sandy beach and pine forests, beckons, while in Capalbio you are awaited by golden beaches—ranging from wild, nearly untouched natural beaches to fully furnished bathing beaches. Some of the most beautiful beaches are found on the coast of Scarlino; for example, the popular Cala Violina. But small, unknown coves are waiting to be discovered too. Some of these can be accessed only on foot, by bike, or on horseback. In the winter the shore is veiled by a special charm equally waiting to be explored.

INSIGHTS:

The lodges are for adults only. You can book trips on-site, as well as rent bikes, MTBs, and e-bikes. The following train stations are nearby: Follonica, 6 mi. (10 km); Campiglia Marittima, 12.4 mi. (20 km); and Grosseto, 25 mi. (40 km). The nearest airport is Pisa's Galileo Galilei airport, 93 mi. (150 km) away.

Prices:

https://www.bevedetta.com/en/ luxury-glamping-vedetta-lodges/

Get a true feeling for Tuscany by spending the night close to nature (*above*). The tents are fully furnished with bathroom, HD-TV, and A/C (*below*).

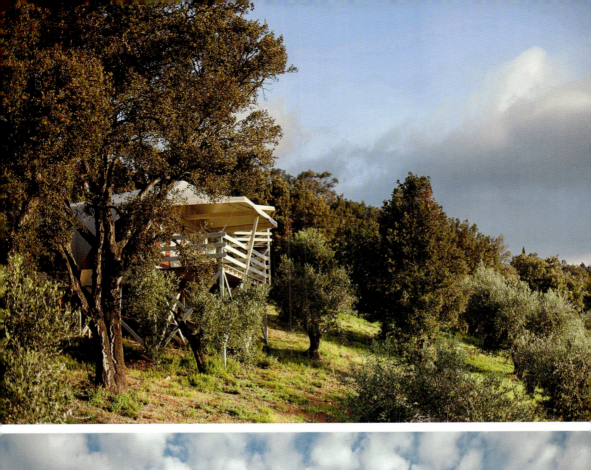
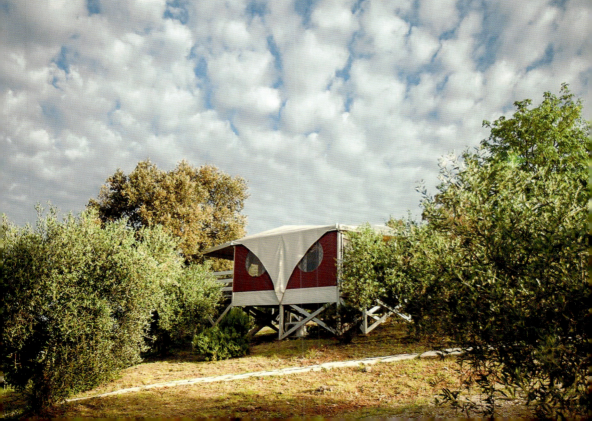

Novanta 90

A Village Wakes from Its Enchantment

Imagine a room without walls, without a ceiling, and without windows, but with a large platform and a four-poster bed. In the very heart of picturesque Tuscany, entirely framed by nature, the SkyLodge is a special gem.

If this bedroom sounds like magic, the place to which it belongs sounds just as magical. The Novanta 90 was founded in a village that has a history of more than 1,000 years, but it was abandoned in the 1950s. It is situated high above the forests of Foreste Casentinesi National Park in the eastern part of Tuscany. A ruined castle completes the picture-book atmosphere. The history of the Novanta 90 begins in 2014, when four friends from Amsterdam opened a pop-up hotel in the deserted mountain village of Borgo di Gello for one summer. The mix of the location, the authentic flair of country life, and the cooperation between young creatives and locals was successful, and thus the hotel became a permanent installation and the village came back

to life. Apart from the unique location and history, Novanta is special because of its welcoming atmosphere. While solitude (time for two) dominates the nights in the SkyLodge, Novanta is a very social place during the day. Whether it is with the hosts, the neighbors, or other guests, it is always easy to start a conversation here. You might end up looking for truffles together or watching a local producer of Italian specialties. The best way to know Italy is definitely through food. In the evening, everyone cooks together, so you even get a cooking class. Afterward the meal is enjoyed together at one long table. The formerly deserted village is again full of life; it overflows with energy, and the atmosphere is simply wonderful.

The food will leave you in a state of happiness, and after a glass of wine or two and lovely conversation it is time for bed. This bed is on a wooden platform on stilts, meaning you have fantastic views into the valley. Above the bed is a Plexiglas pane, so you are protected from any showers.

Dining at a wooden table under the sky. Can it get any better (*above left*)? Ready for adventures (*above right*)? Discover the picturesque valley. (*below*).

Everything else is outdoors, including the bathroom. Here stars twinkle while you fall asleep, while the morning greets you with breathtaking views across the valley and perhaps the most beautiful sunrise of your life. Everything is silent around you. You pass the day with leisurely strolls through the village. The path takes you past the old church to a river that winds picturesquely through the landscape. In the summer you can cool down in the river. Children love to jump into the water from the bridge or the rocks. Then there are some farm animals that want to be petted, and the woods beckon with their cool shade. Woodland walks are a must. You might have a chat with the butcher, or the blacksmith might show visitors how to whet a knife. In this way it doesn't take long until you feel like part of something bigger. It is exactly this mix of remoteness, the rhythms of daily life, the peace and quiet, but equally the community spirit and the opportunity to be creative and active together that makes the Novanta 90 a true favorite place.

INSIGHTS:

The Novanta 90 offers different types of accommodation, from rooms and cottages to tree houses and the SkyLodge—our favorite. The towns of Arezzo and Florence are one and two hours away, respectively.

Prices:
https://www.novanta90.com/

The views across the Gello Valley are spectacular: trees, meadows, hills and ancient towns.

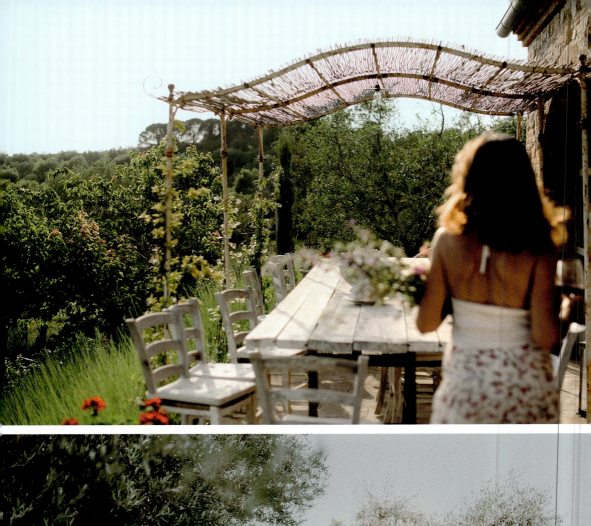
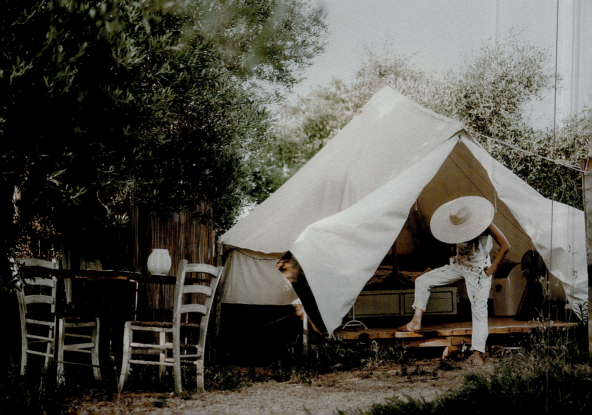

ITALY

The Lazy Olive

Gourmet Glamping in Tuscany

Vineyards, medieval villages, an incomparably beautiful landscape—Tuscany has long been a place of longing. This was also the case for Daniela and Malcolm, who met while traveling in Brazil and decided to settle and create a life for themselves in Tuscany. This is how the gorgeous Lazy Olive was born.

The Lazy Olive is embedded in the idyllic Tuscan landscape. You want to immerse yourself in nature? Happens effortlessly here. A handful of glamping tents sit in the middle of an olive grove. Right from the moment you open your eyes in the morning, you look out across the surrounding landscape, the vineyards, and the

INSIGHTS:

The tents are available from May 1 until September 20. Minimum stay is four nights in July and August, and three nights in May and September. Perugia airport is fifty minutes away, Florence 1.5 hours, and Pisa two hours. Montepulciano is a thirty-minute drive from the Lazy Olive. You arrive at Siena after 36.7 mi. (59 km).

Prices: 🍪
https://www.thelazyolive.com/

medieval village of Pienza. While you are here, you can take a stroll through the vegetable garden, visit the neighboring farm to pet the goats, paddle in the private pool, and go on little trips to the mountain villages and medieval towns. Day trips to Siena or Florence are recommended. Visit ancient monasteries, discover the vineyards, and let Tuscany melt in your mouth with a glass of local wine and some olives. Together with Luciano, the truffles expert here, and his dog Ugo, you can try to find the famous white truffles of S. Giovanni D'Asso. In the afternoon you can then enjoy your foraged treasures on a picnic in the hills while allowing the picturesque views to impress you. Time seems to pass more slowly here; one moment blends into the next in a kind of surreal now. If you go on a wine-tasting tour, you can discover the expensive drops of the Brunello producers. A massage and then perhaps a dip in the pool under the starry sky. The estate sparkles with fairy lights. Doesn't that

Isn't this rather close to the image of a dream vacation (*above*)? The glamping tents stand among the olive trees (*below*).

113

Veronica's Tent

The One-Million-Stars Hotel

A lovingly furnished royal tent, rather like in *Arabian Nights*. When you are sitting together under the sparkling stars and the moon is shining in the sky, wouldn't you love to listen to Sheherazade telling stories?

The tent, modeled after authentic royal tents, is built among picturesque granite rocks and ancient quirky olive trees. On the inside, oriental rugs, a comfortable double bed, and wardrobes and shelves create a homey and exotic atmosphere. In the outdoor kitchen, which was built among scraggy granite rocks, you can work on supper together, to then enjoy a candlelit dinner under the starry firmament. It is much too easy to forget the outside world here, far from everyday life in an environment that could not be more romantic. Dream beaches tempt you during the day, a mere fifteen minutes away. Bizarre rocks, a wild landscape, and a golden beach are the characteristics that turn the Gallura into one of Sardinia's most beautiful regions. The most famous part of the coastline is Costa Smeralda, where the water and the sky vie with each other for the most-beautiful shades of blue. The Macchia will enchant you with its aromatic air, scented with the many herbs and flowers growing here. In spring it turns into a sea of yellow, white, and purple flowers. The hinterland has kept its ancient charm. Nestled among knobbly olive trees and cork trees you will find authentic villages with lived folklore to be discovered.

INSIGHTS:
The tent is in San Pantaleo, inland from Costa Smeralda. Thirty minutes by car from the Olbia airport or from the ferry port. Veronica is also a tour guide and can give you ideas to explore.

Prices: ☺
http://veronicaszelt.de/

The golden sun colors Sardinia's coastline (*above left*). Dinner under the open sky (*above right*). This royal tent has an oriental charm (*below*).

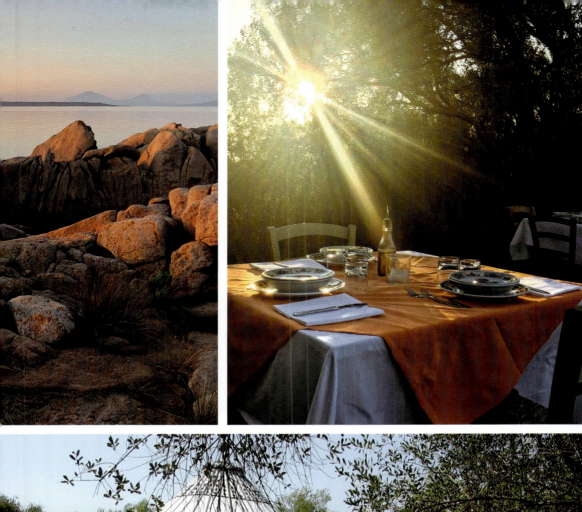
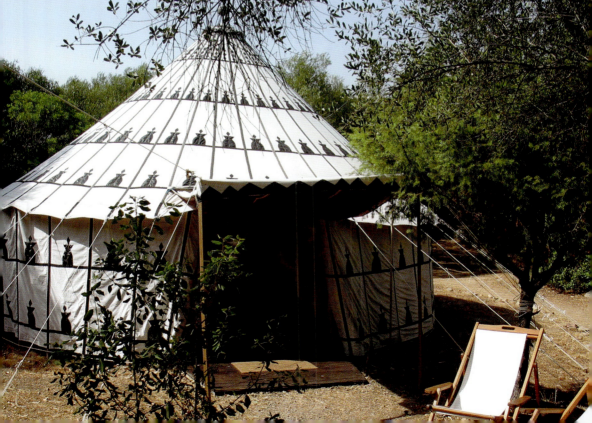

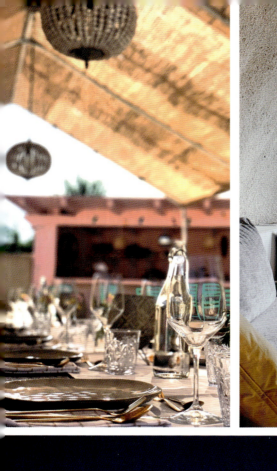

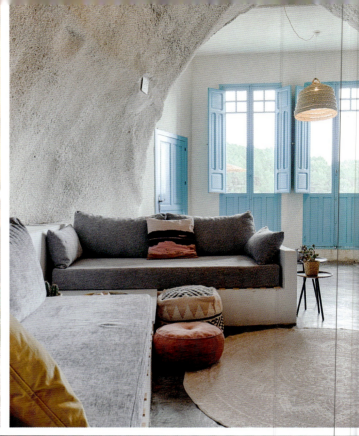

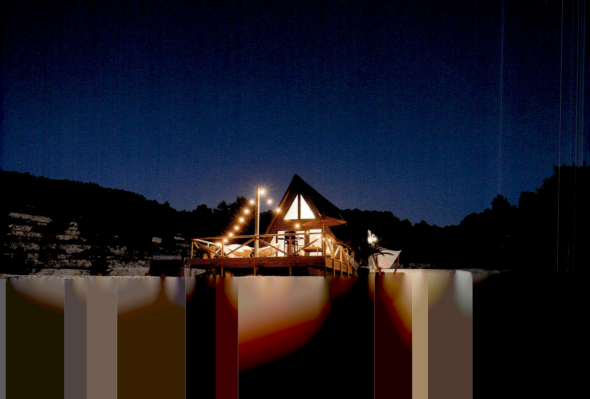

SPAIN

Finca Les Coves

A Cocktail at the Pink Bar

A vacation in Spain far away from the tourist hotels: only half an hour away from the beaches of the Costa Blanca, you can relax by the poolside or in a hammock and treat yourself to a cocktail at stylish pink pool bars.

The Finca Les Coves is an emigration dream come true for three friends originally from Rotterdam. On the 80-hectare estate on the Costa Blanca, guests can share this dream a little bit. A mix of boho chic, upcycling, and fiesta feeling create a chilled atmosphere that shows that style and sustainability can go very well together. Solar panels create energy, the pool is kept clean using salt water instead of chlorine, and the vegetable patch supplies delicious ingredients for vegetarian meals. Despite the hip style, there is no adults-only policy and no party vibes. On the contrary: families with children and pets are more than welcome.

A luxurious safari tent, a traditional Spanish *casa*, a Scandinavian tiny house, or a real cave villa—everyone will find the right accommodation here. You can let the day go by while buried in your favorite book, as the children jump on the trampoline or play with the dog, the cat, and the piglet, who mesmerize all guests. La Carasquetta mountain range, with hiking trails, begins directly outside the estate. At the sandy beach of El Campello, not even half an hour's drive away, you can indulge in swimming and surfing. But the waterfall of El Salt or city trips to Alicante and Valencia are equally rewarding. Even if you are wonderfully away from everything here, it is easy to return to civilization if you feel like it.

INSIGHTS:

It takes half an hour to drive to Alicante, 1.5 hours to Valencia. The beach at El Campello is only twenty minutes away. During the off-season (March, April, and October through December) you have to book at least four nights; during the season (May through September), at least seven nights.

Prices: 💰
https://fincalescoves.com/

In the evening, the poolside becomes the place to socialize (*above left*). Between boho chic and sustainability (*above right*). Night falls on the Costa Blanca (*below*).

Otro Mundo

Vacation in Another World

The whitewashed walls set off the brown, red, and orange hues of the interior textiles. Round forms dominate. These stylish domes combine a '70s retro look with ecotourism—a perfect match.

The environment around the stylish domes could not be better suited to the entire concept. The Eco Dome Camping Otro Mundo is in the most beautiful Spanish Sierra del Segura. Peace and quiet reigns. The mountain landscape is breathtaking. Gentle hills here, rugged rocks there, dotted with knobbly olive and almond trees, large pines, small shrubs, and flower meadows in spring. All of this taken together makes for the ideal conditions for a camping vacation with that glamour factor of the 1970s. The family-run oasis is a peaceful retreat among wild and untamed nature. Otro Mundo means "another world." If you close your eyes and take a deep breath, you will smell the savory herbs and the fresh mountain air, and when you then disappear into your eco-dome hut at night, you will truly feel transported to another world.

Not only were the dome huts furnished with a sure sense of style, but they also offer all the amenities while at the same time following eco principles. Cozy beds, retro armchairs, and a bathroom with an eco-friendly compost toilet and a solar-powered shower await you. Thanks to the building technique, the huts remain pleasantly cool even in the intense heat of the Spanish summer. In the shared areas with a shaded veranda, you will easily strike up a conversation with other guests, and in the shared kitchen the olives, apricots, etc. from the garden are immediately turned into delicious meals.

INSIGHTS:

Apart from lots of room to relax in, there is a pond for swimming, a trampoline, and a sand pit so that the kids also get their money's worth. Breakfast is offered, and you can book dinner on Wednesdays and Saturdays. The airports at Alicante and Murcia both are about 2.5 hours away by car.

Prices: ☁
http://www.otro-mundo.com/

Like from another planet: the domes at the Otro Mundo

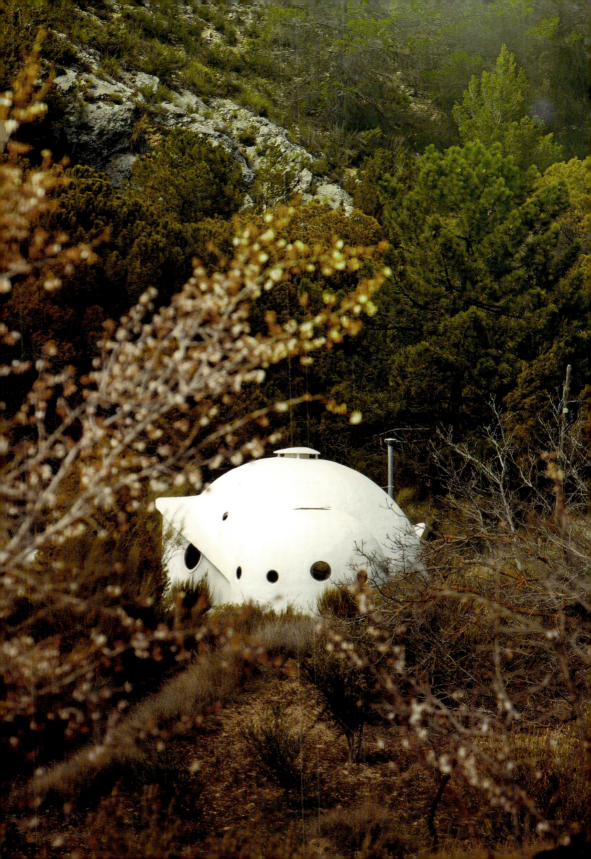

Nomad Xperience

In the Footsteps of the Nomads

When I get the urge to travel, I often think of the feeling of complete freedom that takes hold of me whenever I find myself lying in a little hut far away from the world, no matter whether that is in a bungalow on the beach or in a hut in the mountains. It is exactly this travel feeling that you get at Nomad Xperience.

Only 12.5 mi. (20 km) from Granada, you will travel in the footsteps of nomadic peoples, all within sight of the legendary Sierra Nevada. Because the Nomad Xperience is literally about that. The concept takes its cues from nomadic peoples from around the world, more precisely from Native Americans, Mongolian clans, traveling Roma, and the Inuit.

INSIGHTS:
The minimum stay in July and August is three nights. Children under three are free. Granada, the nearest city, is 12.4 mi. (20 km) away.

Prices: 🪙
https://nomadx.es/

In the tipi, complete with cowhide rug, you immerse yourself in a North America of bygone days, the yurt prayer flags conjure up Asia, and through the opening your eyes can rise straight up to the sky. In the wooden Xiglu, you are beamed to the highlands of Mongolia; in the travelers' wagon, every square inch oozes with the spirit of the traveling peoples. Our favorite? We can't decide. One thing is certain: here you can take everything down a gear and sidestep your normal life completely for a few days. It is so good to take time out! Even if an international flair is strong here, Andalucia is ever present. Numerous beaches await you, the Rio Verde offers opportunities for canyoning, and of course the Sierra Nevada hiking trails and climbing routes beckon.

A childhood dream come true: the tipi (*above*). Every accommodation reminds you of a nomadic people in the world (*below*).

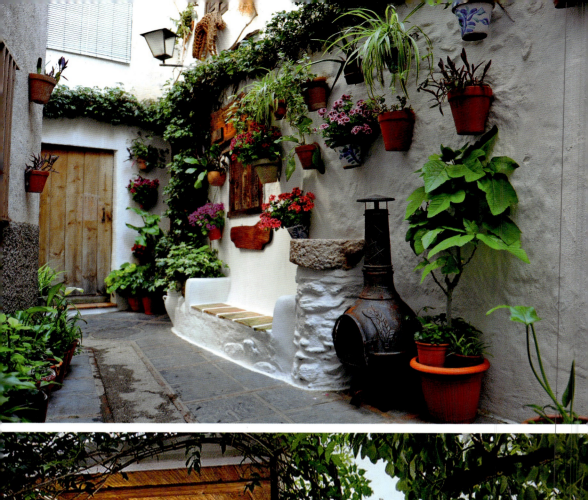

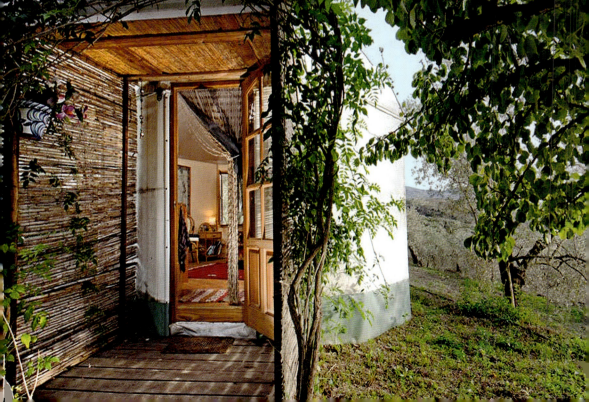

Armonia Alpujarra

Healing, Retreat, and Return
to Harmony

Sometimes we need more than a few days' vacation. Sometimes it is about our essence, and we need healing and rest for body and soul. Surrounded by the mountains of the Sierra Nevada, the Armonia Alpujarra in Andalucia, Spain, is the perfect place for yoga classes, massage treatments, or countryside walks.

Yair and Ziza, both from Israel, met in California, where they were studying different forms of alternative healing methods and complementary medicine, such as reflexology and acupuncture. They returned to Israel as a couple and started a family. A few years later, they decided to move to Spain and to settle here with their family and work. In their own treatment and retreat center, they can be close to their clients as well as to nature. A place was born where they are fulfilling their vision and offering their guests an oasis and retreat from the stresses of everyday life. Here in the mountains of Andalucia, you will breathe the fresh mountain air and help your body, spirit, and soul with yoga and treatments to find peace to heal and find new energy.

The breathtaking mountain range of the Sierra Nevada forms the backdrop for the Armonia Alpujarra Healing Retreat. You have true 360-degree views here, surrounded by olive trees and the sparkling stars by night. Apart from the treatments, you have lots of free time to cool down in the pool, to retreat into the hammock, or to read or relax on a stroll through the olive and almond groves.

The accommodations are designed in such a way that you can feel completely at one with nature. There is not only a Spanish *casita*, but also a close-to-nature yurt with that special something. There are two yurts here, a big one and a small one. Both have those breathtaking views across the snow-covered mountains. Both yurts were built sustainably and in an environmentally friendly way. They are spacious, and at the same time they emanate a sense of safety and security. At night the eyes travel up to the stars, while during the day the sunlight lights up the interior of the traditional round tents—simply beautiful.

Succumb to the magic of Andalucia (*above*). Devote yourself to the well-being of your soul, far away from everyday life (*below*).

If you are open to naturopathic treatments and excited about energy readings and yoga, you will find a place here where all your energies are realigned and harmonized. You can book individual treatments, participate in a yoga retreat, or book a private retreat. But even if you are not into the treatments on offer, you will enjoy a few quiet days in the yurt, surrounded by nature and total peace and quiet. This will definitely convince you that this is a special place. On trips into the surrounding area, you will discover Andalucia's full charm. Whether high up on horseback, superfast on a mountain bike, or windsurfing on the beaches—so far every visitor has succumbed to the charms of Andalucia.

INSIGHTS:

Lanjarón is east of the Lecrin valley, about 24.9 mi. (40 km) from Granada in Sierra Nevada National Park. Go to the home page for info about retreats. The yurts can be booked as accommodation without retreat. Minimum stay is two nights.

Prices:
https://www.armoniaalpujarrarentals.com/
or
http://healing-retreats-spain.com/

Every corner will tell you that nature grounds you.

Lima Escape

At One with the North of Portugal

Savory, sweet, and somehow reminiscent of a sauna—the smell of the forests here is unique, and its effect is instantly relaxing. If you are equally excited about the perfume of the trees, the Lima Escape in the north of Portugal is your place for contemplation.

At the western edge of Peneda-Gerês National Park, deep river valleys and colossal mountaintops shape the landscape. The horizon is lined by oaks and pines. In the middle of all this is the camping ground called Lima Escape, which offers enough space so that everyone can have their place among the trees. Apart from the pitches, there are a number of glamping tents and bungalows in picturesque locations among the trees, with views across the river. The tipis are our favorites; they exude such a spirit of adventure.

The north of Portugal has a pleasant climate, and the environment is greener than in the south. Discover mountainous Peneda-Gerês National Park on walks, bike rides, or hikes. The national park extends over four dramatic peaks. In early summer the landscape is colorful, with thousands of wildflowers in bloom. Roaming through the mountains, you might see ibex or buzzards, you hear the calls of the eagle owl, and even wolves and Garrano ponies live here in the moors of the park. With tired feet you then return to Lima Escape, where you have earned yourself a delicious burger at the bar. A cold beer, then off to the tipi, where you can put up your feet outside on the porch, looking out over the river.

INSIGHTS:

Pets and children are welcome; extra beds can be added to the booking. Lima Escape is about 62 mi. (100 km) from Porto and 7.5 mi. (12 km) from the towns Ponte da Barca and Arcos de Valdevez. On weekends between May and the end of September, you have to book for a minimum of two nights; in July and August this also applies to bookings during the week.

Prices: 🪙
www.lima-escape.pt

Allow yourself to drift through the arteries of the green landscape (*above left*). Fall asleep listening to the rushing of the river (*above left*). Here you can see it clearly: the north of Portugal is much greener than the south (*below*).

Bukubaki Eco Resort

Surfing, Skating, and Mindfulness at the Silver Coast

You can see the wave coming, and at the right moment you start paddling. Quickly you draw yourself onto the board, and you stand—that is the moment when endorphins flood your body.

Once you have caught the surfing bug, it will never leave you. When you are in the waves, water in your face but fully concentrated, then everything else is irrelevant. Only the present moment counts. Everything that might preoccupy you outside the water is blown away, or rather washed away by the waves. Bukubaki Eco Surf Resort is a small but beautiful surfers' paradise in Peniche, a former fishing village, and today one of the most importing surfing spots in the world. If you are into surfing, you will be familiar with the name. Bukubaki Eco Surf Resort combines a range of things that we like. To be a bit more precise: the love for riding waves, surfer vibes, skating, an intimate atmosphere, and sustainable glamping accommodations. All those things have been combined here into a colorful bouquet, and they fit rather well!

Not only are the glamping tents gorgeous, but they have also been designed in such a way as to keep their ecological footprint small, without detracting the least from comfort and style. Building materials have been left untreated, and electricity is generated from renewable energies. The choice is among tree houses, tents, and bungalows of different sizes. The generous tree houses offer—depending on the house—room for four to six guests. The Canadian tents perfect the glamour-camping experience with cozy beds, stylish interiors, and the feeling of still being outside in nature. For the colder months there are electric heaters and warm comforters, so that it stays warm and snug in your tent. Depending on the tent, there is room for two to four people. But it does not matter where you spend the night, since the chilled atmosphere permeates every corner of the resort. Sports activities, mindfulness, love for nature, relaxing, and community all go

Surfing, skating, yoga: sports are big in the Bukubaki (*above*). In the eco resort, sustainability marks every aspect (*below*).

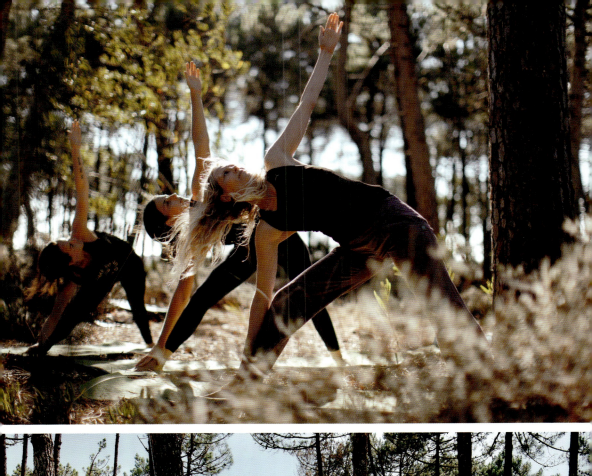
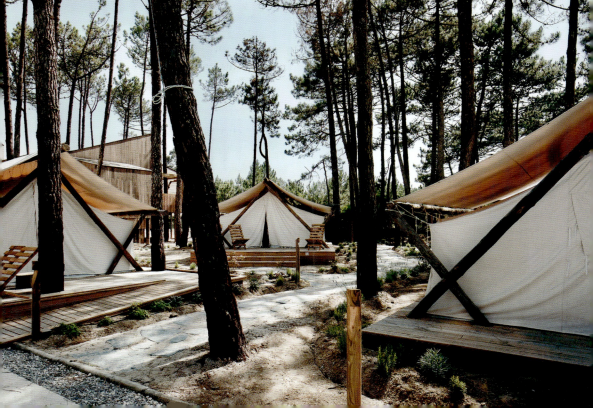

together here, and without any stress, for here at the Portuguese Silver Coast, living in harmony with nature and well-being both come easy. The Bukubaki is a meeting place for all those who share a passion for the boards, whether surfing or skating. Experienced teachers give classes in surfing, skating, yoga, and Pilates. Apart from the surf camp, there is a skate bowl, an outdoor deck for yoga and Pilates, therapeutic stretching, and "surf balance." And just to make sure you come down from your adrenalin rush, there are opportunities to meditate, have a massage treatment, or use the saunas, where you can relax muscles and mind. And when you are then sitting on the beach in the evening, tired but happy and content, the cliffs behind you, the Atlantic Ocean in front of you, and salt in your hair, you will probably confess that you are 100% happy.

INSIGHTS:
Bukubaki Eco Surf Resort is near Peniche, on the Silver Coast, only an hour from Lisbon and the airport.

Prices: 🎴
https://www.bukubaki.com/

Up and onto the board: in the Bukubaki, people surf and skate with a passion.

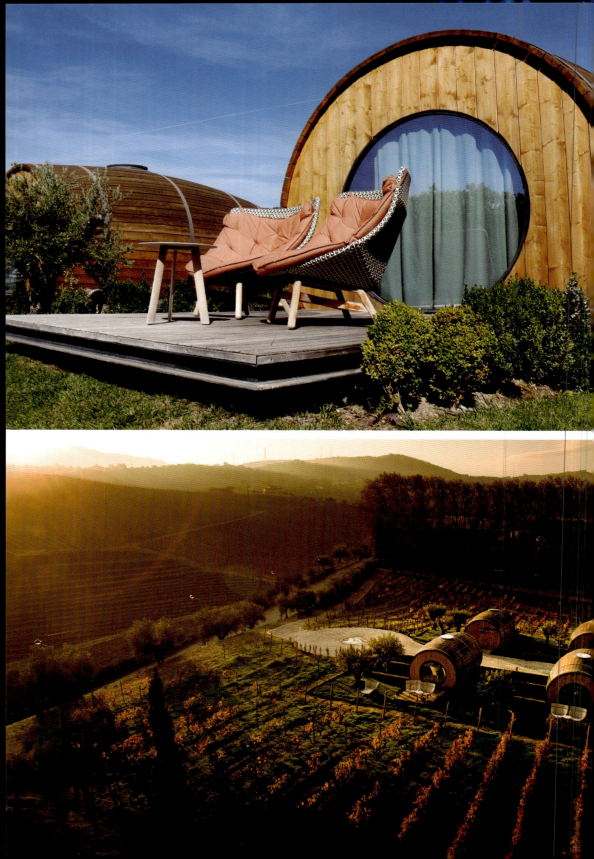

Quinta da Pacheca

Vacation for Wine Lovers

If you love wine, listen to this: in the Douro valley, not only do you find fantastic wines, but one of the oldest vineyards also offers for the perfect wine trip the most suitable accommodation—that is, in a wine keg.

The Doura flows through northern Portugal, and with the Alto Douro you will find in this area one of the most famous wine-growing regions in the world, designated a UNESCO World Heritage site since 2001. The wine kegs belong to Quinta da Pacheca, one of the oldest vineyards in the Douro and a pioneer where bottling their own wines is concerned.

The special wine keg is rather spacious at 323 sq. ft. (30 m²). There is room for a double bed, a small bathroom, air-conditioning, and a skylight. And there is a porch, where your glass of wine will taste even better. The highlight is the glass window at the front, enabling you to look out over the vines from your bed. Just imagine waking up in the morning, and the first thing you see are vineyards! That in itself already sounds pretty picturesque. When the sun shines over the vines, it's time to embark on a tour of the 75-hectare wine-growing estate. Tasting is of course mandatory. Allow yourself to be swept away by the diversity of local wines and try the different Douro DOC and port wines. In every pore of the vineyard, you will feel the rich history of wine growing, but the estate combines tradition with modern design. A picnic in the vineyard or a cookery course completes your wine vacation package.

INSIGHTS:

Apart from the wine kegs, there are also rooms in the exclusive wine hotel. The airport at Porto is about 43.5 mi. (70 km) away, around 1.5 hours by car.

Prices: 🛢️
https://quintadapacheca.com/

Relax with a bottle of wine in the evening (*above*). Everything is about the wine (*below*).

Quinta do Catalão

Fall in Love with the Interior
Parts of the Algarve

Spending the night in a tent in the wild throws us back to childhood days. We feel free, we live with the rhythm of the sun, and time dissolves.

As outdoor fans we love the feeling of freedom in nature, but camping grounds can sometimes be more like well-organized allotments with a strict regimen. Lucky for us, there are such places as Quinta do Catalão in Portugal, where camping becomes a real outdoor experience. Here on the Algarve the memories of summer camp mix with those of vacation on a farm, and that in the best sense possible. This eco farm on the Algarve is simply a happy place. On the 2.5-hectare estate you will see chickens picking their way around, ducks quacking, goats leisurely chewing the grass, a cat catching mice, and a dog lazing in the sun. Organic fruits and vegetables are available in abundance, and a pool invites you to take a plunge into the cool water. A sandy beach to bury your toes in is just a stone's throw away. If you've not fallen in love yet, you will when you see the tipis. There is a large tipi and one for the children to play and sleep in, and they give the whole place a Wild West flair, while also signaling a cozy comfort. There are "real" beds and sofas, and in the separate children's tipi there is plenty of space to play. But wooden huts, shepherd's huts, and the farmhouse are also available as accommodation. There is no Wi-Fi, so you can really concentrate on the essential things in life: spending time together, discovering the Algarve away from busy coastal towns, and enjoying time on the farm. It may surprise you how quickly you feel at home here.

INSIGHTS:

The family-run organic farm Quinta do Catalão is only an hour from Faro airport. There are glamping accommodations, and the farmhouse has room for bigger groups. The beach at Praia da Luz is only a short drive away. Minimum stay is two nights.

Prices: 🥫
https://quintadocatalao.com/

A space to feel good (*above left*). After sundown you can settle down on the porch (*above right*). From the fields of the organic farm directly onto the plate (*below*).

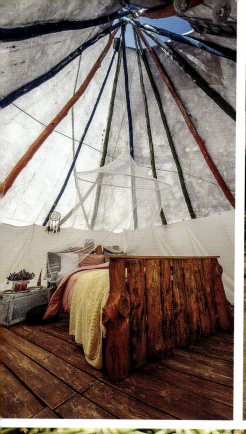
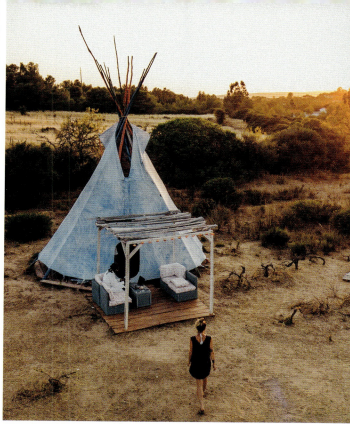
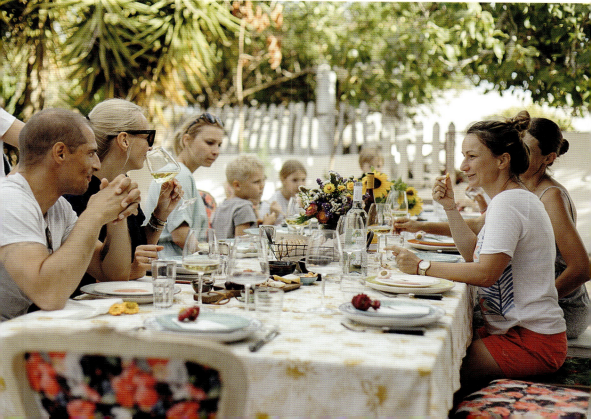

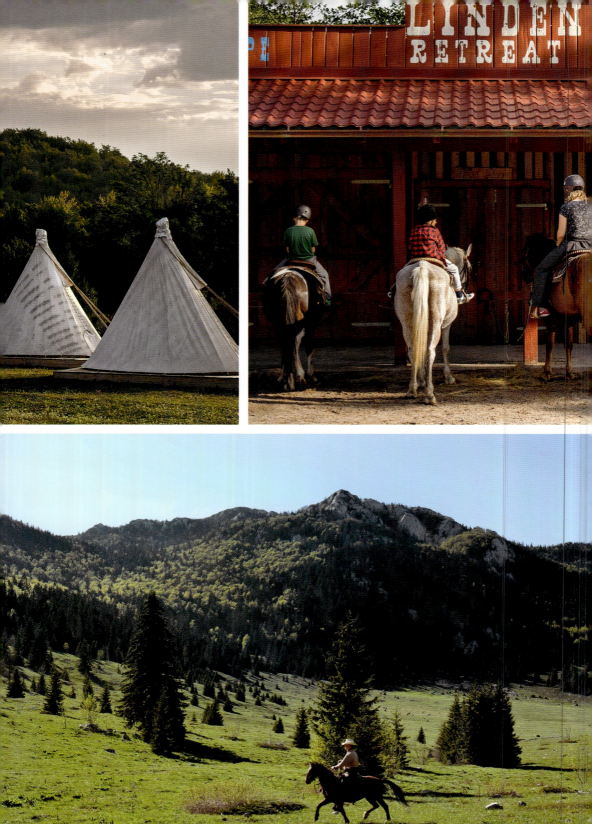

Linden Tree Retreat & Ranch

We Play at Wild West

You love old western movies, or you used to play at Wild West when you were little? At the Linden Tree resort you get the full program: horses, ranch, and tipis.

In the heart of the UNESCO biosphere reservation on Mount Velebit, in Velika Plana, Linden Tree Resort & Ranch is situated on an estate of 50 hectares in an area of breathtaking wilderness. The luxurious eco resort is a place where childhood dreams come true and horse fans really get their money's worth. The founder of the ranch had a vision of creating a retreat that would slot harmoniously into its surrounding environment, and at the same time he wanted to bring to life a kind of Wild West life as seen in movies. The accommodations suit this vision: the tipis are in the proper style. Surrounded by nature, you fall asleep to the snorting of the horses and wake up to the twittering of the birds and the first rays of the sun. If it rains, it is snug and dry inside, while the soft drumming of the raindrops on the tent roof soothes the soul. At night, especially during full-moon nights, the shadows of the trees nearby are painted on the wall covering, and when the sky is clear the stars twinkle through the tent poles. Alternatively, there are rooms in the wooden house, or chalets with generous extra space. Discover the impressive landscape on the backs of the horses on guided treks. Linden Tree Resort & Ranch is known across Croatia for its particularly well-bred herd of horses.

No matter whether you are going for a riding lesson, short rides, or all-day tours on horseback, or with the covered wagon, everything will make the rider's heart beat faster. But even if you are an inexperienced rider, you are in the right place here. The staff will assist you with a lot of knowledge and warm support.

Authentic accommodation in a tipi (*above left*). Horse fans will get their money's worth (*above right*). The perfect backdrop for your trek (*below*).

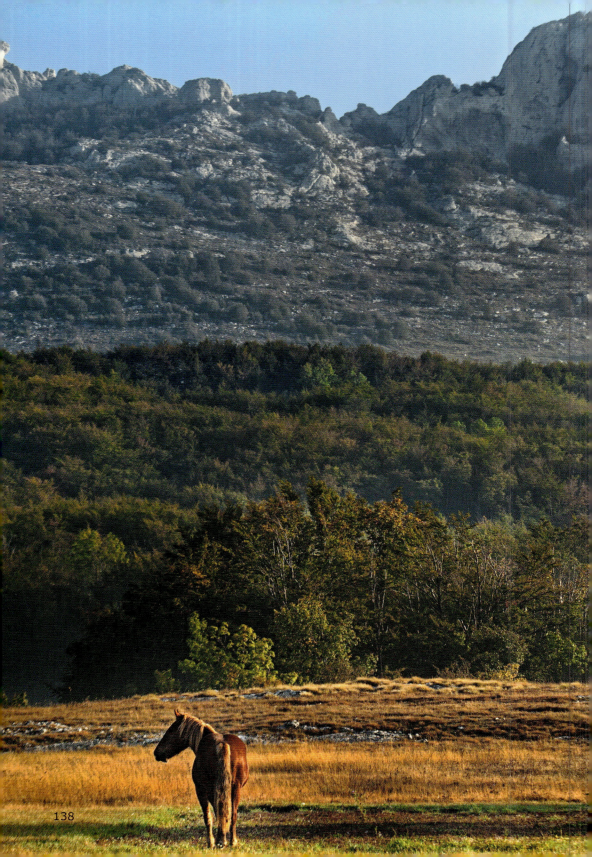

The region forms the perfect backdrop for your Wild West experience: the Velika Plana valley and the adjoining Lika plain are a true idyll with their beautifully green landscapes and unique vegetation. You will find a great range of tours not only on horseback, but for hikers too. Among the most favorite destinations are the "Bear Cave" and "Vila Velebita" cave nearby. Climbing the Ostrovica rock is also worthwhile; the views into the valley are amazing. Biking tours take you through the Velebit mountains, with their colorful meadows and deserted villages. Even the birthplace of Nikola Tesla can be visited on a biking tour. The ranch itself is a place for the entire family.

Everything revolves around that western feeling. You can try archery, cowboy games, American dancing evenings, and much, much more for an all-round western package. Evenings take place authentically around the campfire.

INSIGHTS:

Zadar International Airport is an hour away from the ranch; Zagreb and Split, two hours. The nearest town of Gospić and North Velebit National Park are around 14 mi. (22 km) away. The ferry port Jablanac, with a connection to the island of Rab, is 33 mi. (53km) away.

Prices: 🪙
www.lindenretreat.com

The Velebit mountains' forests and meadows offer an extensive area for riding and hiking.

ALBANIA

Lake Shkodra Resort

The Perfect Summer
Vacation in Albania

A well-kept lawn in the English style, camping pitches in the shade, everything sparkling clean, and a private sandy beach on the lake. It doesn't come as a surprise that Lake Shkodra Resort in Albania is among Europe's most favorite campsites.

For most of us, Albania is still largely unknown territory. If you combine Croatia's rough beauty, Greece's ruins, and rural Italy, you get Albania. The low prices are the real treat when you plan this vacation. The location directly on the lake is picturesque. A long wooden jetty projects across the water and invites you to jump into the cool water. The largest lake in the Balkans extends across 25.5 mi. (41 km) between Montenegro and Albania. Whereas human beings like to use the lake to swim, boat, or windsurf, birds still use it as a refuge. Two hundred species of birds live here, among them some of Europe's last remaining pelicans. In the summertime the lake is a sanctuary for 1.5 to 2.5 million birds.

We leave the camping ground aside and turn our attention to the glamping area, and here we find a kind of best-of glamping accommodations. Outdoor fans who like to be close to flora and fauna but do not mind taking a dose of luxury with it will find the right accommodation in the safari tent. Instead of camping mats and sleeping bags, there are real beds with sprung mattresses. Africa and safari feeling is included in the price.

The tree house and shepherd's hut are particularly snug, and the lodge is the first choice for all those who like things a bit more spacious. This extravagant wooden lodge has space for four people in two bedrooms, a generous living room, and a balcony.

INSIGHTS:

Lake Shkodra Resort is directly on the lake, 4.3 mi. (7 km) from the center of Shkodër. The capital Tirana is a 1.5-hour drive away. The glamping accommodations can be booked between April and October.

Prices: 💰
https://www.lakeshkodraresort.com/

The tents are only one possibility for glamping (*above left*). The lake is the pivot of all leisure activities (*above right*). Camping has nothing to do with tiny igloo tents here (*below*).

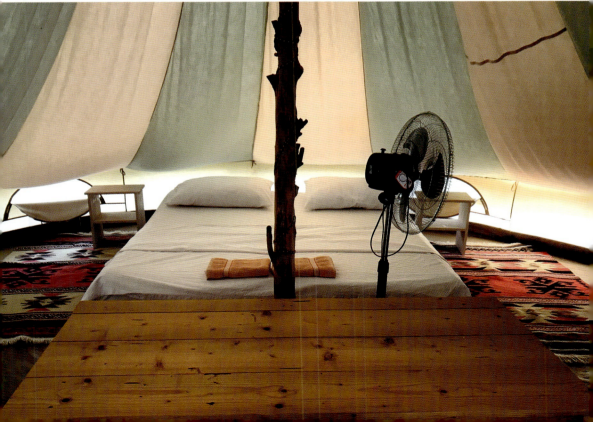

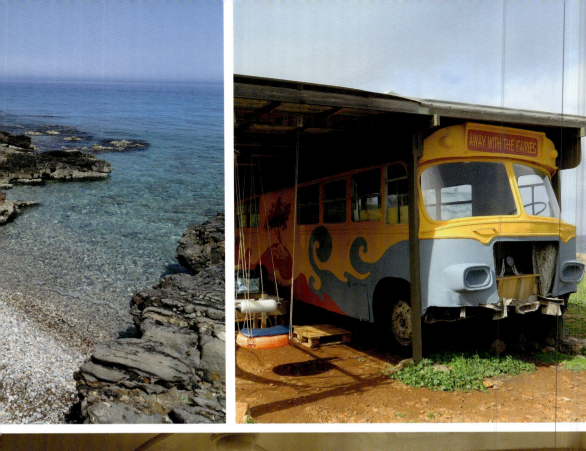

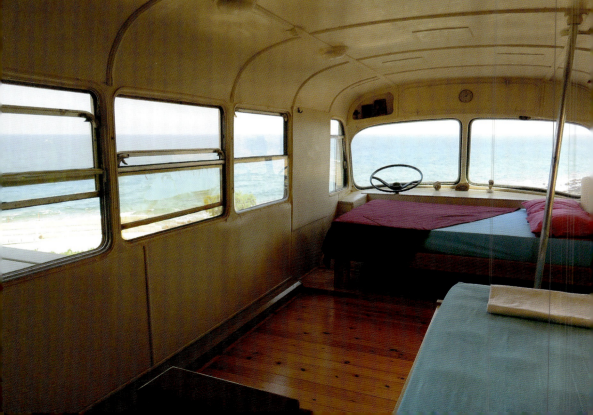

The Old Bus

Where Hippie Hearts Beat Faster

On a peaceful part of Crete's coastline, there is a place that seems somehow magical. A lonely bus is parked here directly by the sea. From the inside you can look through the windscreen directly over the sea and the horizon, from sunrise to sunset. The Old Bus is far from all civilization. Not only is the bus a place to spend the night; it is a special experience to be here. It becomes your sanctuary, around you nothing but sea, sky, and shore. Here is a space to just be, look at the stars, turn inward, and immerse yourself completely in the magic of this place. If this sounds heavily esoteric, during your stay in the Old Bus it becomes an authentic experience. When you wake up in the morning and look through the front screen window to see the sea surge, you may feel that things are rather surreal. Time spent here feels like a road trip. You simply stay where you like, and where you can be completely alone with nature. Even without moving anywhere, you achieve that feeling here. Dora and Giorgo, the owners, describe the time in the bus as a journey, as a place outside time, where you can lose yourself completely in the blue of the sea. "You come with the ferry and go with the fairies," owner Dora says. Okay, perhaps you have to have a bit of a hippie heart in you, but if you do, the Old Bus is heaven on Earth.

The water here on the coast is crystal clear (*above left*). A hippie dream in the shape of a bus (*above right*). The interior of the bus is rather spacious (*below*).

INSIGHTS:
The bus is on the northern coast of Crete, only one hour and ten minutes by car from the airport Heraklion. In the Old Bus and Studio there is room for a total of four people. Electricity is generated by solar panels.

Prices: 💿
http://theoldbus.simplesite.com/
or **https://www.airbnb.co.uk/**

Agramada Treehouse

Greece with a Minimal Eco Footprint

A short ride with a 4×4 jeep, then you have to continue on foot to reach one of the best-kept secrets of the area: the Peristeri waterfall. It is a strenuous hike, but worth the effort. Nature's rough beauty rewards you amply.

At the waterfall you will find not only well-earned refreshment, but also a delicious picnic to refuel. At the end of the hike, there is even an opportunity to taste the wines in a local vineyard. Then you return "home" to the Agramada Treehouse, a unique luxury sanctuary in the heart of Chalkidiki, in northern Greece. The accommodation is close to an old traditional Greek village. Far from the crowds, the tree house is a tranquil retreat nestling in gentle hills. Inside Greek design, as in the gorgeous bathroom tiles, meets a rustic and very cozy tree house style.

But not only is the Agramada Treehouse a great place to switch off; its owners also take their ecological and social responsibility very seriously. This includes the way the houses are built, the cosmetics provided, and the food served. Only local materials were used for the construction of the houses, and local businesses supported. The water comes from their own well, and solar panels provide the majority of the energy used. The goal is to support a kind of tourism that leaves only a minimal ecological footprint. As an ideal starting point for discoveries, you can not only hike to the waterfall from here, but also trek to antique ruins, explore the gentle hills, and relax by the crystal-clear water.

INSIGHTS:

The nearest airport is at Thessaloniki, which is 54.7 mi. (88 km) away. A taxi service can be organized, and there is also a bus that connects Thessaloniki with Palaiohori.

Prices: 😐
https://www.agramada.com/treehouse

The area offers diverse hiking trails (*above left*). The path to the waterfall leads through the forest (*above right*). You do not need a lot of space to feel great (*below*).

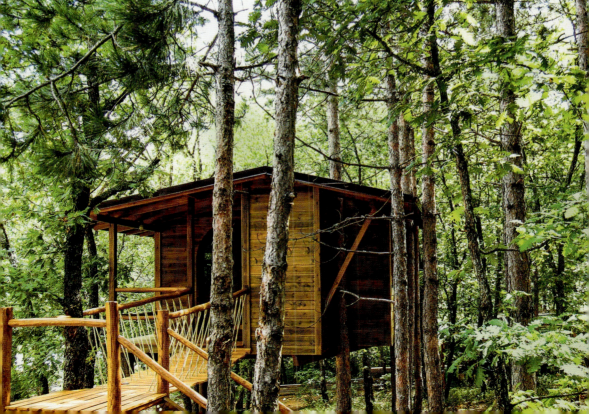

East

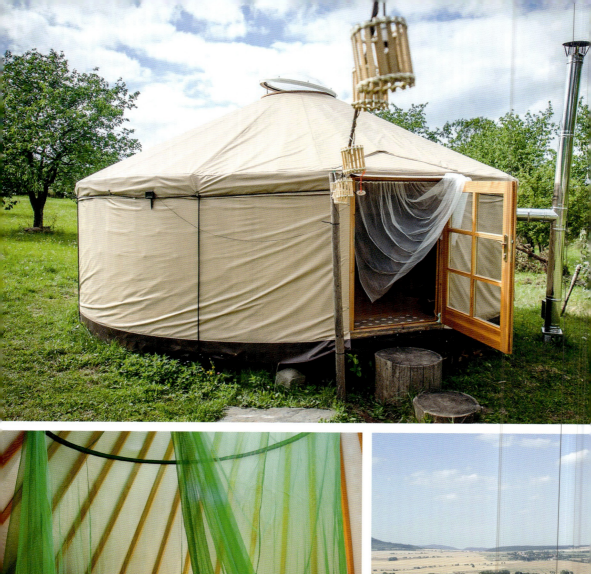
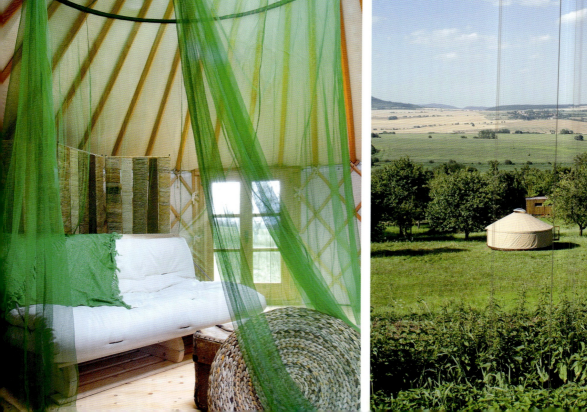

HolidaYurt

Nomad Nights

A wooden frame with a textile covering; that is basically all you need for this characteristic round tent. Everyone should spend at least one night in a yurt in their lifetime, for they represent the perfect mix of adventure and comfort.

These tents that originate with the nomads of Mongolia have long become a special accommodation around the world. And this experience in the round tent is particularly easily accessible. Only 50 mi. (80 km) from the German border, in a little village called Chlum in the west of the Czech Republic, is the HolidaYurt. The yurt is perfect for a self-catering vacation, for example, with family or friends who need time away from city life to immerse themselves in nature. Apart from a kitchen with a fridge and stove, there is also a fireplace for cooler days, since the yurt can be booked all year. In the winter, when you all get cozy inside the yurt, spending a night here is an even-deeper experience.

The spacious grounds around HolidaYurt are another plus. There is an enormous meadow with lots of room to play and relax, a fire pit for the evenings, separate sanitary facilities, and a pavilion—and all this is exclusively at your disposal when you book the HolidaYurt. The surrounding area offers a range of trails for cycling and hiking. If you are planning trips farther afield, don't miss the world-famous baths of western Bohemia, such as Karlsbad and Marienbad, both around 25–28 mi. (40–45 km) away. The region, with its different underground springs, is perfect for a relaxing spa day. The therapeutic qualities of the hot and cold springs have been known for the most part since the twelfth century. Of course, you can also taste the water of the 230 developed springs, and you will discover that spring water comes in many different varieties!

A night in a yurt is a special experience (*above*). Tons of space for sleeping, reading, and relaxing (*below left*). The rural parts of the Czech Republic guarantee peace and quiet (*below right*).

If you prefer to discover the area closer to the yurt, there is a lot to do here too. You can go fishing, go horse riding, or get to know the village. Even though Chlum has only thirty inhabitants, there is much to discover. Chlum was first mentioned in a document in 1115, and the church is from the fourteenth century. Chlumska hora mountain offers a fantastic view of the village and the surrounding area. The nature reserve on the mountain invites you on a discovery tour where you may find wild Siberian iris. Even the ancient beech trees bear historic relics: here you can find incised names going back as far as 1925. Countess Lazanska was fascinated by the mountain, too, and had a nature bath built here exclusively for herself.

INSIGHTS:
Karlsbad airport is 18 mi. (29 km) away. It is 62 mi. (100 km) to Prague. Cannot be booked in winter. The yurt accommodates four to five people. Minimum stay is two nights.

Prices: 🛢️
http://holidayurt.com/
or
https://www.airbnb.co.uk/ rooms/675736/

Karlovy Vary, or Karlsbad, is a real gem. A visit is worth it.

Glendoria

Country Life in the Style of the 1920s

When the mist hangs over the meadows in the morning, the world seems a particularly magical place—especially here on the Masurian lakes, a land of 1,000 lakes, where the mist comes from the water. This lake district in Poland is no longer a well-kept secret, but in the Glendoria you are both at the heart of everything and yet far away from the crowds. Here at the end of the road, on the edge of the forest and the lakes, far from the tourist places, you will find an outdoor jewel. Totaling 50 hectares, with meadows, hills, grassland, and lakes, this is a near-perfect image of summer vacation. The Glendoria is a place for time travel. Here in the country you feel transported to the 1920s. Perfect for slowing down! Agrotourism in a refurbished barn from 1924 in combination with glamping and the amenities of a good hotel—that is the concept in a nutshell. It means you will spend nights in gorgeous glamping tents and days on the idyllic farm, and you can always make things even better by taking advantage of the outdoor spa treatments. Apart from a Finnish sauna in the middle of the forest, there is also a hot tub and a flower bath. If you ask me for suitable things to do while here, and the best vacation program, I can recommend only one thing, and that strongly: doing nothing. Lying in the sun, swimming in the lake or the pool, and reading your favorite book while having a glass of wine. Taking a sunset walk, smelling the forest, allowing your thoughts to wander, having a romantic candlelight dinner with your loved one, or enjoying a movie night in the barn—doesn't all of this sound fabulous?

INSIGHTS:

There are five glamping tents with bathrooms and lots of privacy on the grounds. The Glendoria is open from mid-May through September. During the season, minimum stay is seven nights. The nearest town is Olsztyn, 16.7 mi. (27 km) away.

Prices: 💲
http://www.glendoria.pl/

When did you last really experience a sunset (*above left*)? Relaxation here definitely includes a bath in the open air (*above right*). Catch up on sleep (*below*).

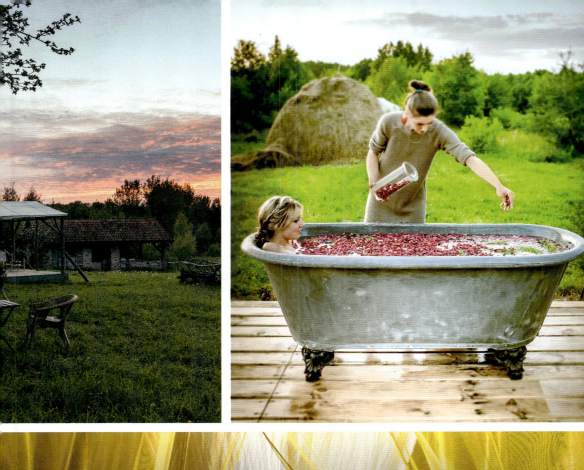

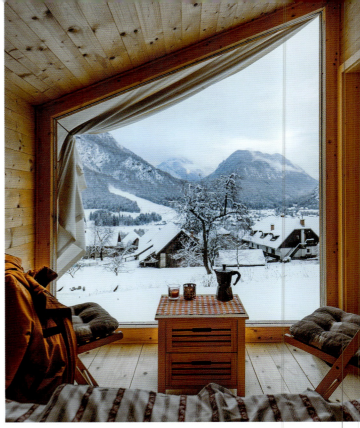
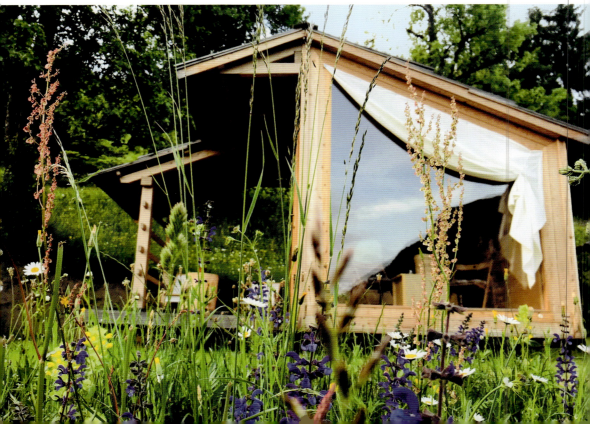

Mountain View Glamping

Window into the Julian Alps

Dovje, in the Gorenjska region, is said to be the area that gets the most sunshine in Slovenia. Additionally, the town is most idyllically at the foot of the Julian Alps. That in itself already sounds promising, but if your heart starts skipping a beat when you hear the term "tiny house," then you will be completely bowled over when you set eyes on Mountain View Glamping. The best thing about this little house is the glass front, because it means uninhibited views into the outdoors. Everything follows the principle of minimalism here. Purist design with a focus on the essentials. Downgrading and slowdown mentality are recent trends that are realized to perfection here. Apart from a bed and a place to sit down, there isn't much else in the hut—the outdoors is the star! Nothing inside should detract from the mountain views. But this can still be rather comfortable. A small porch guarantees sunny mornings and evenings and provides that relaxed vacation feeling. By the way, there is no electricity in the hut. You will find the sanitary facilities in a separate building, where you can even charge your mobile phone and use Wi-Fi. But I would recommend you use your time here to give another trend a chance: digital detox! When your day starts with a view of the green outdoors, and the Triglav range is framed by the glass front as if it were a painting, you will start the day with a smile on your face. What a view! A cup of coffee in bed and you are ready to start the day. In the summer you will walk barefoot across the large flower meadow and pick a few wildflowers while gazing into the distance again and again. You can easily spend the whole day near the little house. But actually the area has too much to offer for that. Climb the highest mountain in Slovenia, get on a bike, or try the popular climbing routes in Mojstranan.

This dream backdrop is better than any TV program (*above left*). Whether in the winter or the summer, the mountains always fascinate (*above right*). How about a guided walk where you learn about wild herbs (*below*)?

Slovenia's national parks, with their waterfalls and abundant nature, are waiting for you. In the winter you can ski or discover Slovenia's wintry landscape by toboggan—a sled without skids. And in the evening, things get really cozy. You can light up a barbecue with wood and charcoal and cook your supper authentically over the fire. Enjoy a glass of local white wine that the owners provide to every guest. The rest is provided by nature: the chirping of the crickets, the crackling of the fire, and the dark night sky with millions of twinkling stars. Days like these fill our happiness account to the brim.

INSIGHTS:
The nearest airport is Ljubljana, 29 mi. (47 km) away.
Prices: ⊜
https://www.booking.com/hotel/si/mountain-view-glamping.html
or
https://facebook.com/mountain.view.glamping/

The panoramic view from the window is like a photo wallpaper, only much more beautiful!

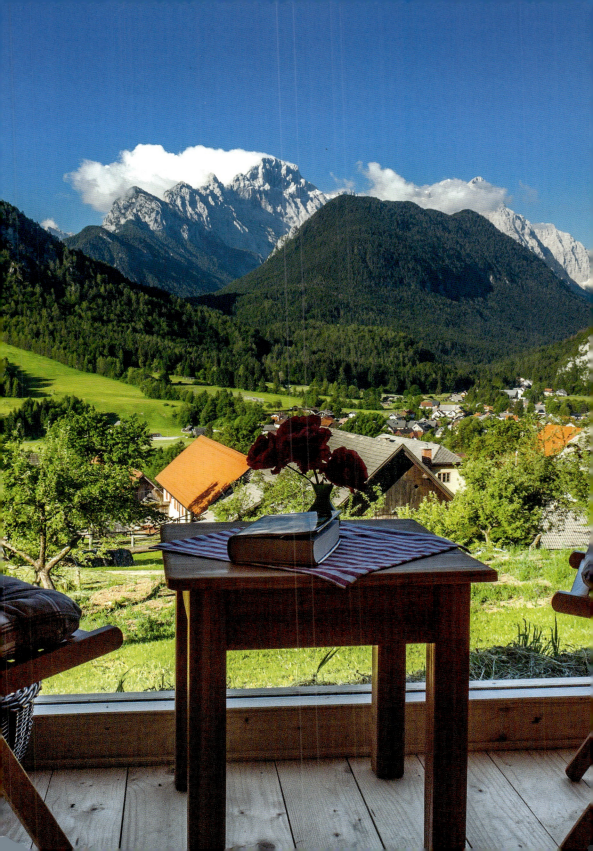

Garden Village Bled

Experience the Luxury of
Nature in Bled

Behind most glamping accommodations is an interesting story. They often represent somebody's dream, and sometimes you get the feeling that the small huts, tents, or tree houses would, if they could, tell you this or that anecdote. This is definitely the case at the Garden Village in Bled. If you walk across the corduroyed paths to the tree houses, you can nearly hear the tree trunks whisper.

The fabulous houses and glamorous tents are lovingly set in Slovenia's natural landscape. When you walk to your tent, you can feel the soft lawn under your feet, and in the tree houses you can hear the rustling of the leaves as the wind carves its path through the treetops. Nature itself is all the luxury here. But to provide the perfect vacation experience and to pamper the guests a bit more, there is a choice of five different types of accommodations, each ecologically designed and furnished with those wellness extras. There are glamping tents among fruit trees, with a traditional wooden tub that becomes a relaxing oasis when filled with hot water. But the apartments with massage tub, the tree tents with adventure kick, the traditional Slovenian tree houses with built-in hammocks and balconies, or the pier tents with their beautiful porch directly on the little river, will all equally make you swoon. You already noticed it: we simply cannot settle on a favorite accommodation. Not only with the accommodations, but with the food, too, sustainability is taken seriously. In the fruit and vegetable gardens the fruits shine from afar, and the air is pregnant with the sweet scent of the apples, which simply taste best directly from the tree. All produce, grown far away from mass production here, finds its way into the on-site restaurant. But you are totally allowed to pick and taste berries, herbs, etc. This makes a stroll through the garden even more enjoyable. But you shouldn't miss a visit to the restaurant. All the dishes are made following the guidelines of local, high quality, and homemade. Enjoy traditional Slovenian specialties with a fresh, modern note and authentic taste.

Vacation for the entire family (*above*). Great food makes for a great vacation (*below left*). The Garden Village in Bled offers the perfect blend of camping and luxury (*below*).

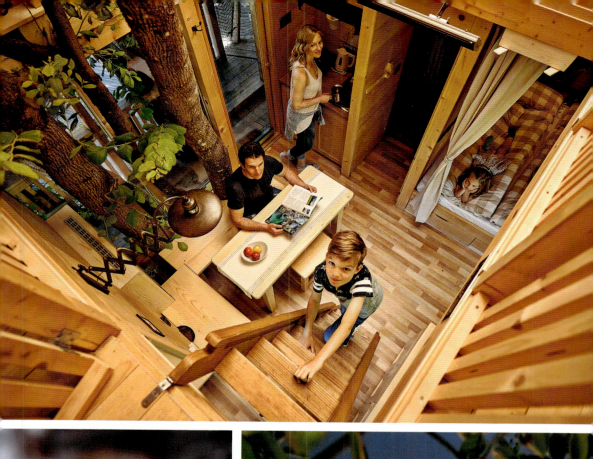

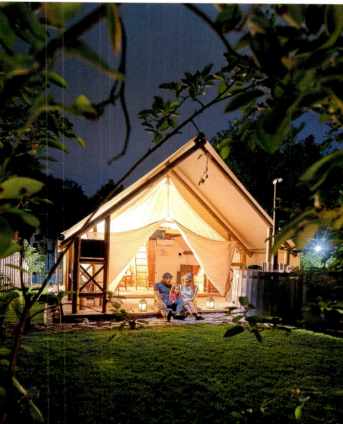

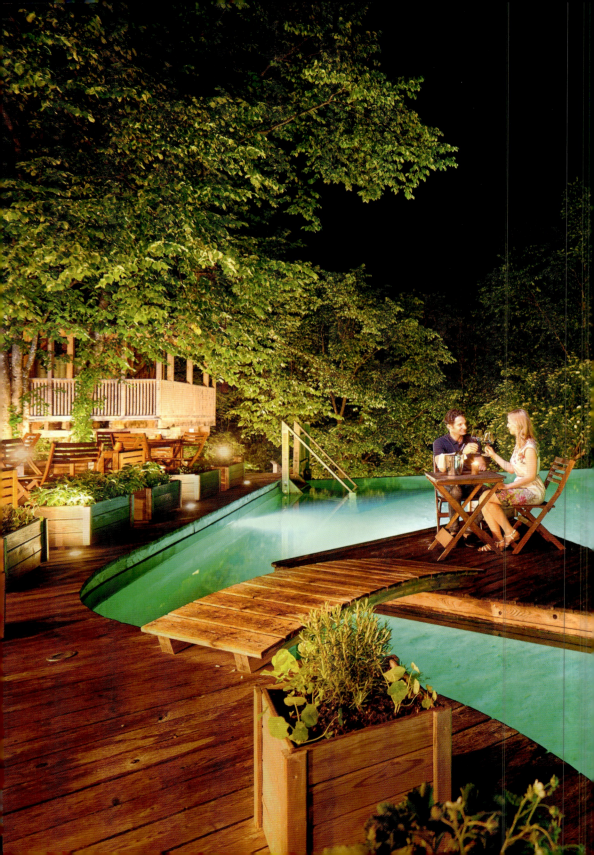

Not only is the Garden Village a place that has its own story to tell; it is also a place where new stories are written. There is gorgeous beach on the little river, and Lake Bled is only 1,000 ft. (300 m) away from the grounds. In the Garden Village you can swim your laps in a pool filled with spring water, ramp up your metabolism with Kneipp therapy, and finally put in a visit to the Finnish sauna up in the treetops.

Whether quiet boating trips or canyoning, stand-up paddling or diving, peaceful strolls at 656 ft. (200 m) above sea level or a mountain hike at 6,500 ft. (2,000 m) above sea level, Bled offers outdoor experiences in abundance. Whether it is quiet moments or adrenalin highs you are after, both come with the best mountain air here.

INSIGHTS:

Bled is close to the Austrian border, on the edge of Triglav National Park. Ljubljana is around 31 mi. (50 km) away.

Prices:
https://gardenvillagebled.com/

A special candlelight dinner for the evening

Hunza Ecolodge

Fairy-Tale Vacations in Hungary

A place like a fairy tale—Hunza Ecolodge seems too beautiful to be true. Let's start with the glamping accommodations: First, there are the atmospheric glamping tents, which have been furnished with an eye for detail and create a safari mood. Then there is the tree house, with its views across the valley, which here in southern Hungary is so wonderfully green. But you can also sleep in a little hut in the forest, reminiscent of a witch's gingerbread house. Additionally, there is room for your own tent or camper, where you can allow yourself to be equally enchanted by the Hunza vibes. The family-run business has its own special atmosphere that is difficult to describe. You feel at once how much love and care has been invested in every square inch. Behind it all are the owners, who immigrated to Hungary from Ghent, Belgium. They have

thought through every detail. The Ecolodge is inspired by travel, by the meeting of different cultural backgrounds, and by the preciousness of nature. The owners see in their tourist business a responsibility. Sustainable building types with local materials were prioritized, and native builders were involved who contributed their knowledge of local building traditions. The garden provides crunchy vegetables and juicy fruit, so shared cooking parties involving all guests can happen regularly. Everyone cooks and then everyone eats at the large table. Breakfast with homemade bread and produce from the garden completes the picture. Just as a glamping tent is the perfect mix of being outdoors and the comforts of a hotel room, the location of Hunza Ecolodge is the perfect mix of nature and culture.

This little house looks as if it came straight out of a fairy tale (*above left*). Nature is the best playground (*above right*). An outdoor kitchen provides for your bodily needs (*below*).

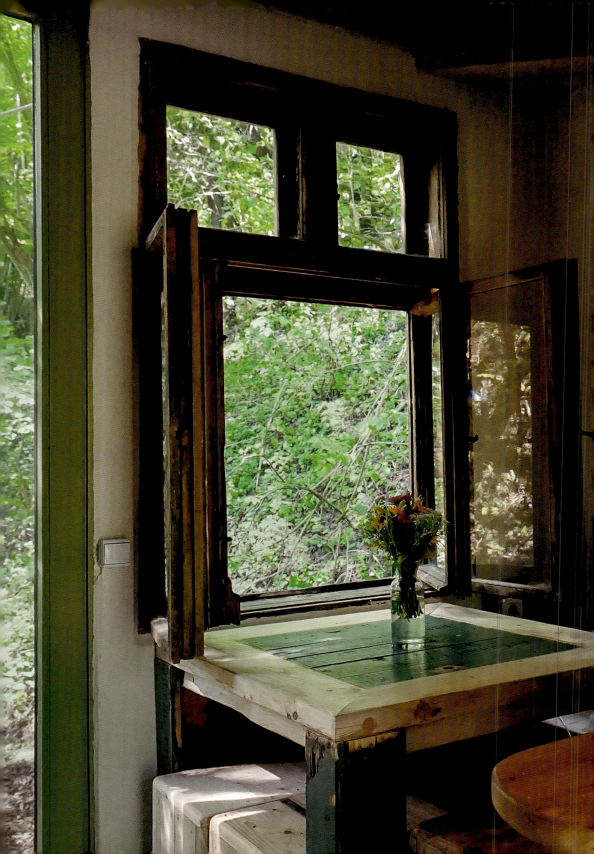

Situated on the edge of a forest, it is only a stone's throw away from the lakes and woods. Whether you walk or cycle, you will find one perfect picnic spot after another here. The area around Hunza, called Baranya, is the southernmost part of Hungary and is known for its hills and long summers. The surrounding area has some of the well-known thermal spas so typical of Hungary. Harkány, not far from the Croatian border, for example, has been known for more than 150 years for its thermal bath with sulfurous water. The water is thought to help alleviate joint problems. But it is equally possible to soak up city vibes here, and that in the most beautiful form: Pecs, a UNESCO World Heritage site, is nearby and one of the cultural centers of the country.

INSIGHTS:
You can get here by bus, train, or plane via Budapest (transfer can be organized), or directly by car. Larger groups can book the entire facility.

Prices: ⊜
http://hunza-ecolodge.com/

In the heart of the forest: the inside merges with the outside.

HUNGARY

Homoki Lodge

Nights on the Prairie

Homoki means "sand" in Hungarian. The name is homage to the ground that forms the Hungarian prairie, where Magyar horsemen first settled, who came from the extensive steppes south of the Urals and eventually founded Hungary.

Homoki Lodge is south of Budapest in the southern plain, a low, sandy basin between the rivers Danube and Tisza. Outside the cities you will find only small, scattered farmsteads and acacia forests, orchards, meadows, and lakes. Passing sunflower fields, you reach the Puszta of southern Hungary. The estate was bought by the current owners in 1997 and continually refurbished. They have wel-

comed guests to their vacation rentals since 2001. Homoki Lodge was gradually extended and spa options were added. Since 2015 you have the opportunity to glamp here in luxury yurts that really suit the landscape. Hosts Birgit and Oliver Christen, both of whom grew up in Vienna, have created a gorgeous retreat that betrays their love for detail. It is evident that professionals—an architect and an art historian—were at work here. The yurts combine tradition with modern luxury. There are several yurts unique in their special design. The domed window can be opened so that the dark, starry sky is fully visible at night. While you might dream of being a belligerent horseman when lying in the yurt, you will feel like a king when sitting in the hot tub or while receiving a massage. The Puszta around Homoki Lodge is one of the best destinations for horse riding. Guided tours take you through a landscape where neither fences nor roads hold up your horse.

ith a jeep through the steppe (*above left*). On horseback through the Puszta (*above right*). Direct views into the night sky through the skylight (*below*).

INSIGHTS:

Homoki Lodge—Nature Quest Resort is 4.3 mi. (7 km) from the village of Ruzsa. The nearest international airport is Budapest's Liszt Ferenc airport.

Prices: 🪙
http://homokilodge.com

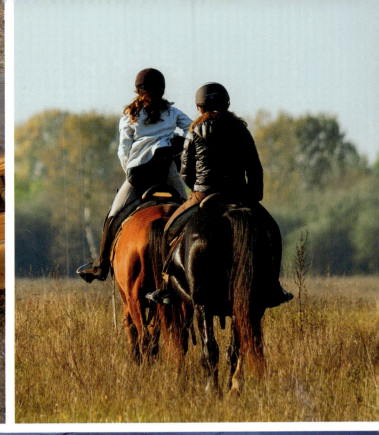
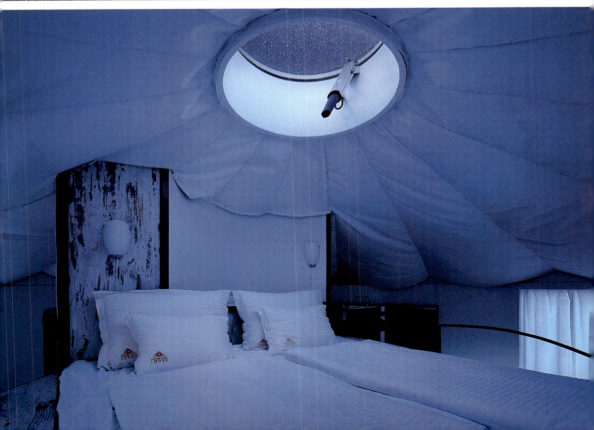

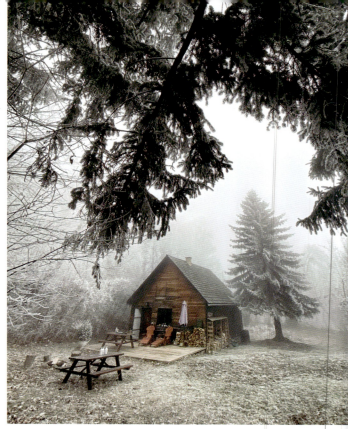

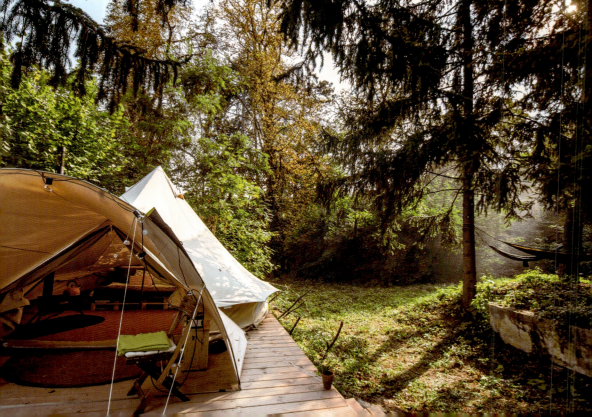

Cabin & Canvas

Wilderness—a Stone's Throw from the City Center

A hideaway on the edge of a forest, and yet only twenty minutes by bus from the city center—that sounds like the perfect mix of city trip and outdoor vacation. The Cabin & Canvas is a place to relax, recharge, and discover when you've had enough of sightseeing. Pompous buildings, elegant cafés, subculture bars—exploring Budapest is always eventful and full of surprises. But leaving the city also has its merits; namely, a break from all the business. When you leave behind the sights of Budapest, there is another experience waiting for you, far from the well-trodden tourist paths. Whether as a cozy winter hut

or summertime out in a tent with sun porch and campfire—leaving the city is worthwhile all year. In the green parts of Buda's XII ward, on the edge of the Normafa nature reserve, you will find this retreat where creative and nature-loving people from all over the world meet. Born from a collaboration between a graphic designer and photographer and an architect, this place invites you to be creative as well as relax. Some people come here to work, and concentration comes wonderfully easy here because it is far from the crowds and noise, but well connected with Wi-Fi. Others enjoy a walk in the woods to clear their heads. Especially in the winter, the wooden hut with heating, kitchen, bathroom, washing machine, and tumble dryer leaves nothing to be desired and offers lots of space for the whole family. The bell tent is a trifle closer to nature. With a wood-burning stove, a double bed, and room for two extra beds, you will feel instantly connected to the earth.

INSIGHTS:

The Cabin & Canvas is about twenty minutes from the city center, next to a large leisure area with walking trails, woods, and viewpoints. Guests are offered outdoor equipment, including a hurricane lamp, binoculars, pre-chopped wood, and a basic supply of food. Minimum stay is three nights.

Prices: 🗄
https://www.cabinandcanvas.com/

Feeling good far from the city noise (*above left*). Even dull weather seems picturesque here in the green ward of Budapest (*above right*). Leave the ordinary; welcome adventure (*below*).

Oaktreehouse

A Traditional Vacation
Destination Reclaimed

Modra lies on the southeastern slopes of the Carpathian mountains. It is an ancient wine-growing town that can call itself a "royal-free town" since 1607. Since then, Modra has developed into one of the most important towns in the country. And yet, it has retained the charming character of a town in the vineyards. Here you can study Slovakian tradition and history as if under a magnifying glass.

Modra is the center of viticulture in the Little Carpathians, and the town with the largest area devoted to wine growing in Slovakia. For the inhabitants of Bratislava it has long been a favorite destination for weekends and vacations. Here the people of the capital have their weekend homes, but guests from farther afield also find accommodation. To really experience Modra at its most authentic, come in the fall, when traditional wine harvest festivals are celebrated. Modra is also called the "pearl of the Little Carpathians," and when you walk through its small lanes you will feel that this is a rather apt title. Among the town's traditional vacation settlements is Harmonia. Despite the ornate name, this area is home to the Oaktreehouse right in the middle of picturesque hills. Harmonia knows its guests. People have come here to find peace and quiet and the pleasant climate of the Little Carpathians, far from the city, since the nineteenth century. The name Oaktreehouse is rather self-explanatory: the tree house is built between four old oaks at a height of about 20 ft. (6 m). No matter whether you come alone, with your partner, with the entire family, or with friends, everyone feels instantly at home! And although the vacation resort is popular, nothing ever feels crowded here. In the tree house your only neighbors are squirrels, salamanders, stag beetles, hedgehogs, and woodpeckers. A wooden bridge leads you directly onto the porch, with a soothing view into the treetops. Inside, a bed settee and a kitchenette await you. The sleeping area is reached via a ladder. There is also a fire pit with a picnic table for your barbecue dinner.

Let your soul breathe (*above left*). Space is used very efficiently in the tree house (*above right*). Wood is also used predominantly in the interior space (*below*).

You want to explore the Little Carpathians? You could rent two mountain bikes from the Oaktree-house and cruise through the hilly landscape. But you could also put on your walking boots. One of the most popular trails leads up to the view tower on the Ve'ká homol'a, about two hours from town. From here you can see far across the Little Carpathians, across the mountain ranges of Považský Inovec and Tribec, and even into the Alps over in Austria. In the winter the area is a popular winter sports resort, especially for Nordic skiing. The Zochov Chata also has a ski lift.

INSIGHTS:
The nearest airport is Bratislava, about half an hour by car from Modra. If you travel by car, you can use the guarded parking lot at the accommodation.

Prices:

http://oaktreehouse.sk/

A place to recharge your batteries

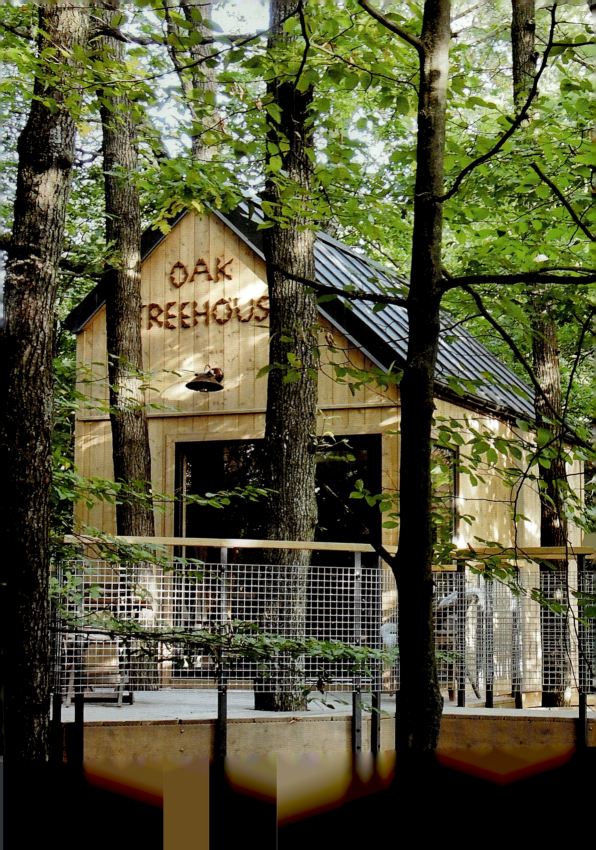

Transylvania Log Cabins

Romania without Dracula

No, we won't talk about bloodthirsty dukes and vampires now. Transylvania is far too diverse and far too idyllic for that. Here, between the Apuseni and Retezat mountain ranges, the beauty of nature is simply overwhelming! But the country's beauty, with glaciers and volcanoes, is only one side. Transylvania is also rich in history, legends, and ancient traditions. The region has dinosaur remains, the ruins of the Roman province Dakia, and Castle Corvin—to name only a few highlights. The accommodation is near the village Pesteana. Here you get the impression that not much has changed since the last century—and that in the best

sense. No busyness or crowds of tourists, just simple country life. The owners of Transylvania Log Cabins have traveled far. They have been to South America and Ireland before finally landing here (again) to turn their dream into a reality, far from the crowds. On an idyllic estate there are several enchanting accommodations. For example, the generous Transylvania Vintage Ensuite or the Transylvania Log Cabin, a Canadian-style log cabin. Additionally there are two tree houses: one small and snug, and the other—the Transylvania Loft Treehouse—a bit bigger and more luxurious. Not only is it furnished tastefully, but it also offers the perfect mix between rustic tree house and comfortable holiday rental. From up here the views go far into the garden, and there is plenty of light, a huge and comfortable bed, a bathroom, small kitchenette, and room to work, including Wi-Fi. But of course we would rather sit outside on the balcony all day, enjoying the space.

INSIGHTS:

Pesteana village is just under 187 mi. (300 km) northwest of Bucharest. The nearest airport is Caransebes, 29.2 mi. (47 km) away. The accommodations are available all year.

Prices: 💰
https://www.facebook.com/ transylvanialogcabins/

The vintage style creates a cozy atmosphere (*above left*). At night the starry sky shows itself in all its glory (*above right*). There is enough space to work and relax (*below left*). Your animal neighbors (*below right*).

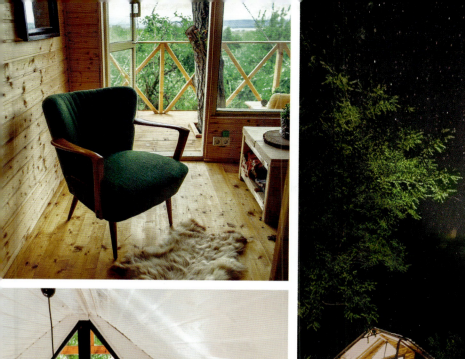
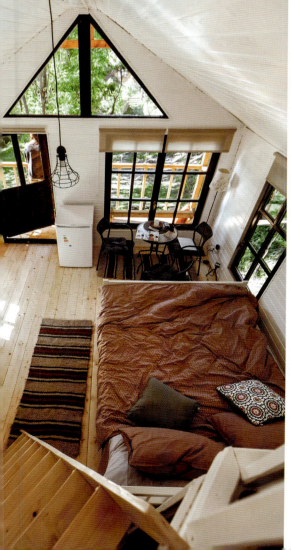

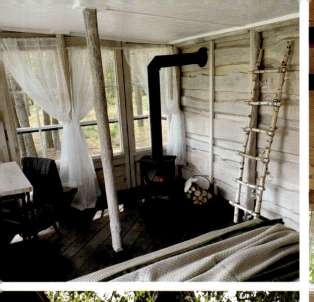

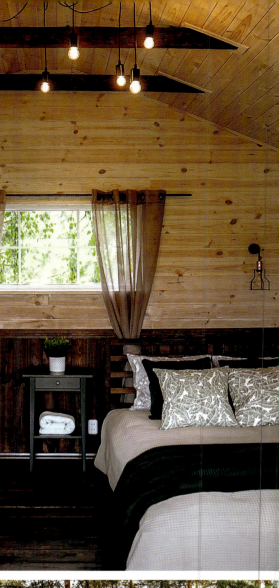

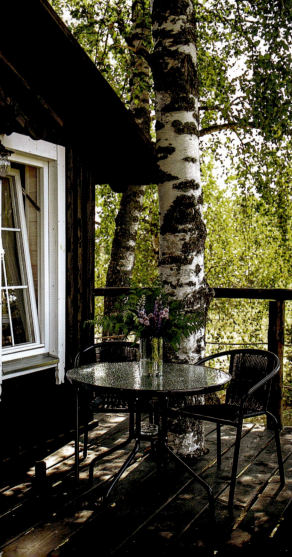

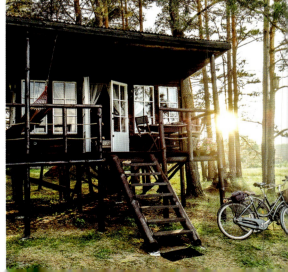

LITHUANIA

Varena Treehouse

Creative Retreat in a Tree House

Vilnius is probably one of the most underestimated towns in Europe. If you come here, you won't stop being surprised. The old town is huge! The impressive university, sweet medieval lanes, pretty coffee shops, and the alternative artists' quarter Uzupis are only some of the reasons why a visit is worth it.

When you have breathed enough city air, you go out into the countryside. Only an hour from Vilnius you will find Varena Treehouse, as yet a real secret. You have the choice between two tree houses: Varena Treehouse East and West. Both are beautiful and furnished with all the comforts, such as a woodburning stove and veranda. If you are dreaming of writing a book and are imagining yourself doing so while sitting in a forest hut in the middle of nowhere, here is your place. But even if you want to take your laptop to retreat for a few days and get some work done in a quiet place without distractions, or if you simply want to have a break from your normal home office for a few days, this is your perfect getaway. Both tree houses have a workspace with Wi-Fi. When you sit at the desk, your eyes can wander among the trees, with only peace and quiet roundabout, maybe with a glass of wine, and inspiration will come automatically. If you have come simply to enjoy a vacation, you can grab a bike and join the offered tour. The goal is the village of Pamerkiai, on the river Merkys. The village seems to have fallen out of time: everything looks like the early twentieth century. Grikucis farm offers traditional cuisine and a varied cultural entertainment program.

INSIGHTS:

The two tree houses are in Varena, in the Alytus region, 29 mi. (47 km) from Alytus and 48 mi. (77 km) from Vilnius airport.

Prices: 🪙
https://www.facebook.com/varenatreehouse/

A fireplace gives cozy warmth (*above left*). There is room even for a large bed in the tree house (*above right*). The perfect spot for a glass of wine in the evening (*below left*). Start discovering on your bicycle (*below right*).

A Unique Tree House for Two

Digital Detox on the Island

Don't we all from time to time resolve to be a bit less digital? To scroll less through Instagram, to stop binge-watching the latest serial every night, and to leave the mobile out of the bedroom?

To do "real" things again, such as finishing the book that has been lying on our bedside table for months. To take a walk in the forest, without our mobile phone. Here in Magi's tree house, digital detox comes easy. The ideal place to finally act on all those resolutions. The tree house is a small escape into the unique landscape of the Baltic Sea island of Saaremaa. The 1,042.5 sq. mi. (2,700 km²) island boasts an environment that is quite different from that in the rest of Estonia. On the chalky soil and in the mild sea climate, a unique flora and fauna have developed. You can explore cliffs and even a meteorite crater. The island is magical, and you should definitely schedule a few extra days in your itinerary to explore it. My tip: plan your stay in Magi's tree house for the end of your trip, when you have satisfied your curiosity and are ready to immerse yourself completely in nature, and when you are ready to really switch off and allow all the impressions from your journey to sink in.

In line with the digital detox program, there is no internet and no electricity in the tree house. Instead you can light a candle in the evening. Heating makes the hut comfortably warm, and from the cozy double bed you can listen to the sounds of the forest animals looking for food in the undergrowth.

It's really worth getting up early here—take it from a confirmed late riser! The sea is only a stone's throw away, and the deserted beaches are the ideal place to watch the sunrise.

Back to basics—back to freedom (*above left*). Cooking is done in the outdoor kitchen (*above right*). Get close to the forest (*below*).

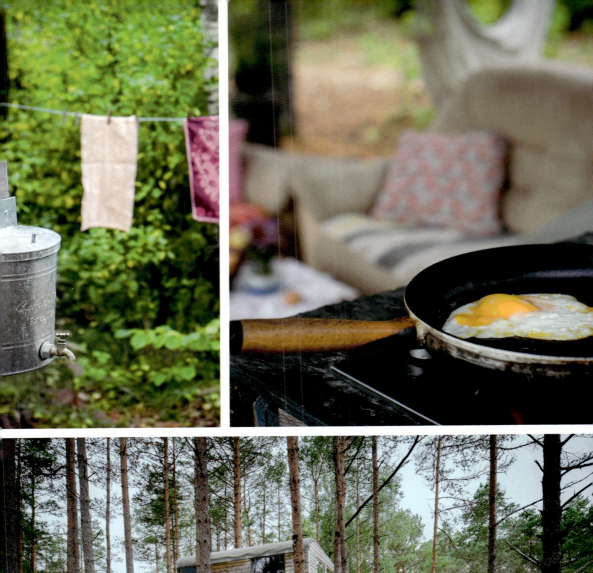
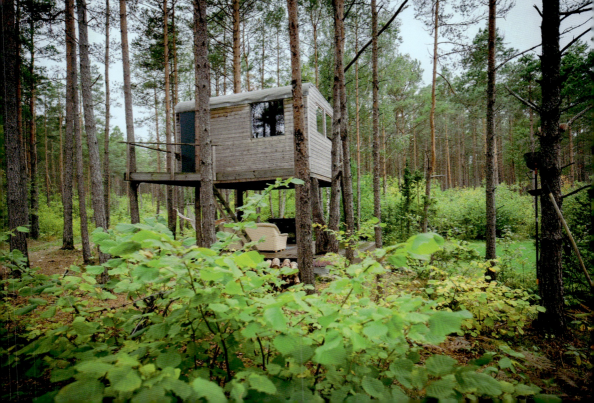

Later you can relax in the hammock and devote yourself to your favorite book. It can be such a luxury to take the time to read without interruptions and to get completely lost in a book. In the little outdoor kitchen with gas stove and grill, you can cook up a simple but tasty supper. When dusk falls, bats will flutter about your head, and nightlife in the forest starts. Some places simply have a special vibe, and this tree house in the forest is definitely one of them! If you are looking for a place for a little time out between the sea and the forest, you have found it here.

INSIGHTS:

Saaremaa is the fourth-largest island in the Baltic Sea and lies on the western coast of Estonia. Saaremaa can be reached from Tallinn by plane, as well as by car ferry from several ports on the mainland. The quickest way to get here is via Virtsu to the neighboring island of Muhu and then via the dam to Saaremaa.

Prices: 🪙
**https://www.airbnb.co.uk/
rooms/20938975**

The lighthouse is Saaremaa's most iconic landmark.

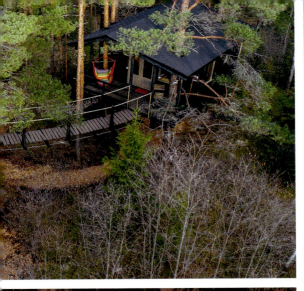

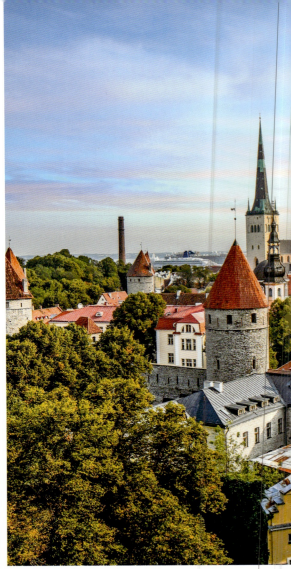

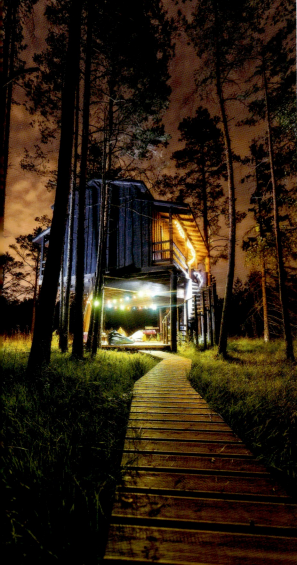

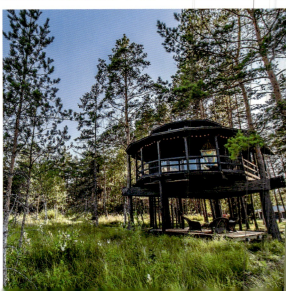

Treehouse Estonia

A Place for Being
Wonderfully Lazy

My favorite place is the hammock seat on the balcony. From here I can look into the forest, I can observe the birds on the branches as they pick and clean their feathers, and I can dream. Swaying gently, I could spend the whole day here. And to be honest, why not? The forests of Koppelmaa, just half an hour from Tallinn, are the perfect place for lazing about like this. Treehouse Estonia has three tree houses: the Treehouse, the Jungle Treehouse, and the Forest Treehouse. You can't go wrong; all three have the fabulous hammock seat. You reach the inside via a wooden bridge, and there, wood paneling and colorful fabrics create an extra-cozy atmosphere—a place to feel at home without having to go without our favorite comforts. Depending on the house, there is a plush sofa or an armchair, and there are cozy beds, a kitchenette, a bathroom, tons of books, a warming fireplace, and a veranda with a fire pit. All conditions to feel 100% comfortable are met.

When you've spent a day doing nothing and your feet start to itch, you might want to grab a board and try SUP on the river. If you feel better in a kayak, you might want to brave the rapids. Back in the tree house after a day on the river, which may mean getting soaked, you can go directly into one of the saunas or settle down in the hot tub.

INSIGHTS:

Tallinn, with its airport, is 14.3 mi. (23 km) from the Treehouse Estonia. The tree houses accommodate two to four people.

Prices: 🪙

https://treehouseestonia.ee/

The porch with the hammock seat is sure to become your favorite spot (*above left*). A gem from the Middle Ages: Tallinn (*above right*). More beautiful than any bar: the outdoor lounge (*below left*). 360° of green (*below right*).

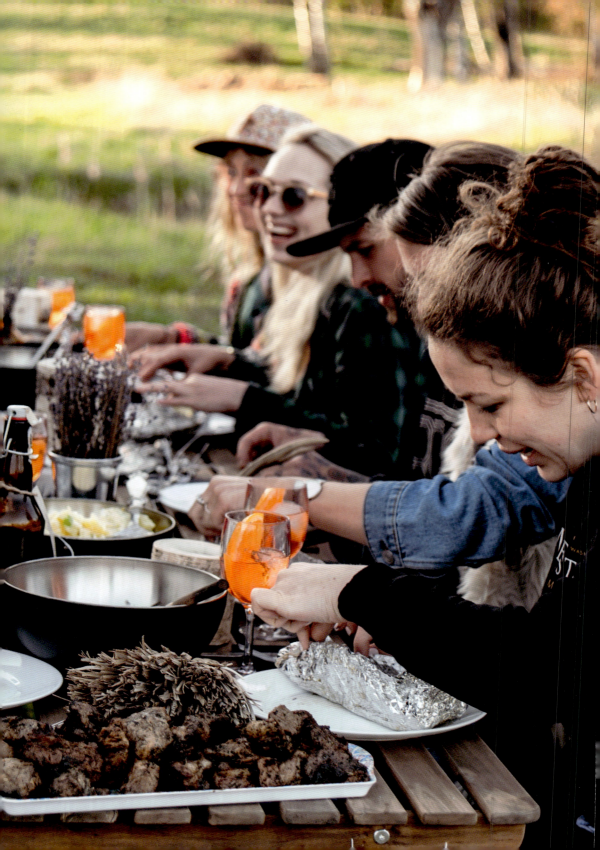

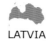

Wild'ness Retreat

Experience 100% Nature, 100% Baltic

You grab the little basket and start off. A quick look into the handbook to make sure it really is sorrel, and the herbs go into the basket. Herb gathering is fun, and the Latvian soup you are going to make later is even more delicious when you've gathered the herbs yourself.

Wild'ness Retreat is a precious gem, and you will think twice whether to share your discovery with others or keep it to yourself. Everything is founded on the basis of a great love for nature. This 33-hectare private forest resort is in the middle of the wilderness of Gauja National Park in the region called Pargauja, also known as "little Switzerland." Here you can retreat, recover from everyday stress on walks in the woods, practice yoga, and simply leave the world be for a few days. Here you have the chance to step back. It is a bit as if you pressed a reset button when everything has become a bit too much. Here you will notice how good it is to value the little things again—such as the quacking of the ducks, smelling the scent of the flowers, and having time for a round of chess. The Wild'ness is also special in its commitment to Baltic culture, especially the food. In Straupe, a town not far away, the Latvian slow-food movement was founded. Around the resort you will find award-winning restaurants and chefs, and Wild'ness Retreat itself feels connected with the slow-food movement. At joint cooking evenings, you can try the typical Latvian herb liquor called "Balsam," Latvian wines, and Latvian cuisine with sausages and cheese. Visit organic farms in the neighborhood or go to a bee farm and learn how honey and candles are made. The Wild'ness works closely with local people and aims to provide guests with an authentic impression of the area.

Enjoy the full outdoor experience with like-minded people (*above*).

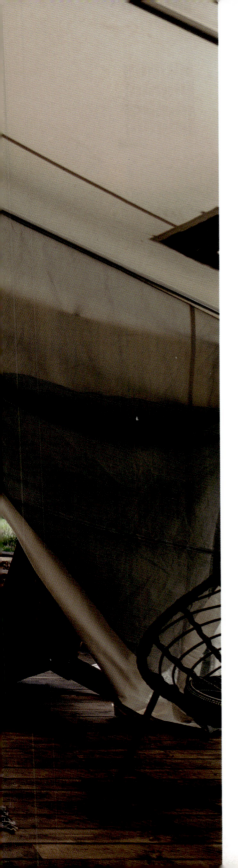

There are two small, enchanting huts for retreating from the world, with views into the green space around. You are even closer to nature in one of the three glamping tents pitched between the trees. Here deer and fox say good morning to you, and sometimes you will hear a woodpecker knock. On the grounds there are ducks, cats, numerous frogs, and, last but not least, sheep who live in a barn that is more than 100 years old. There is no real reason why you should ever leave Wild'ness Retreat while you're here, but if you do want to explore the surrounding area and the national park, you can take a bicycle and admire the endless woods and fields while riding past. Take a picnic basket and take your lunch break by one of the ponds.

INSIGHTS:
Riga, with its international airport, is only about 43.5 mi. (70 km) away. Minimum stay is two nights. Wild'ness Retreat can also be booked for weddings.

Prices: 💿
https://www.wildnesscollective.com/

Waking up in nature is the perfect start of a day

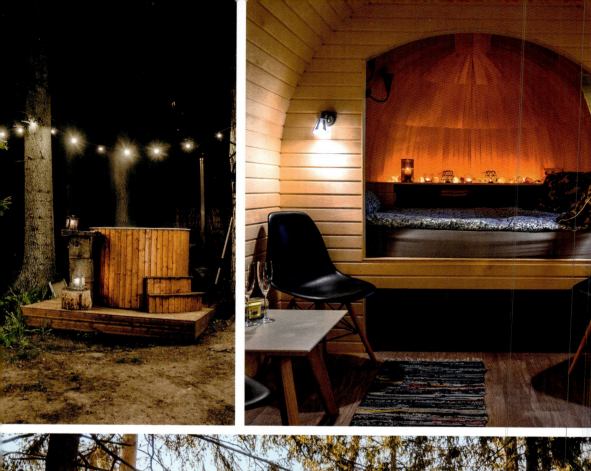

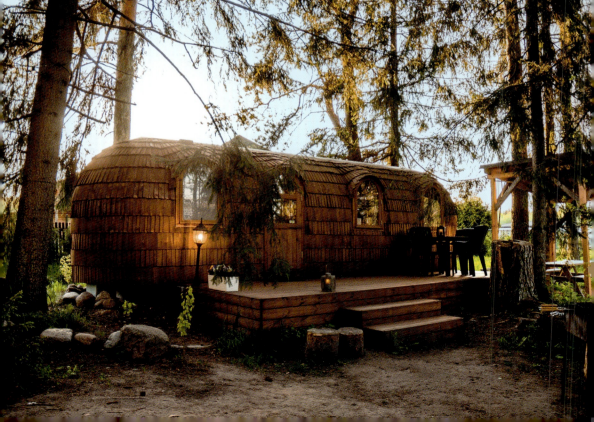

Iglu Hut Milzkalne

A Refuge in the Latvian Woods

In the forest, a hut that looks a bit like a pine cone. Squirrels play in the branches, and in the evening the fox comes past on his daily round.

Only one hour's drive from Riga there is a small, special house in an open woodland. Even if the name suggests a different image to you, when you see the wooden hut in the peaceful Milzkalne, you will be amazed, I guarantee. The tiny house offers everything you need for a perfect time-out. There is a shower and a toilet, a kitchenette with electric stove, a fridge, and even Wi-Fi. Here you are prepared for everything, whether digital detox, a romantic time out in the forest, a working trip with lots of space to think, or simply a place to spend some time with family and friends without distractions.

Outside there is a beautiful pavilion including a barbecue, where you can eat al fresco, read, be creative, or work. A fireplace makes things extra cozy, but the highlight is the outdoor hot tub. Doesn't that sound like romantic nights beneath the stars? Fairy lights and candles cast a warm glow over your retreat. On walks through the forest, you can follow different nature paths; for example, along the river Viesata or Lake Engure. You can cross moors with bridges and follow the wooden plank path to castle Mound. And when the sea calls you, you know you're only ten minutes by car away from the white sandy beach of Klapkalnciems.

INSIGHTS:
Milzkalne is 34 mi. (55 km) from Riga and 3.1 mi. (5 km) from Tukums. It is 6.8 mi. (11 km) to the sea. The hut has a double bed and room for two extra beds.

Prices: 😊
http://www.igluhut.lv/home/

A bath in the hot tub is the perfect ending to a wonderful day (*above left*). In the berth you will dream the sweetest dreams (*above right*). From the outside a gem too (*below*).

Index

Picture Credits

Stine Christiansen: p. 1
Peter Lundström / WDO: pp. 2/3, 25b., t.r.,
Ministerie van Beeld Gorinchem: p. 13t.r., b., 14
Juha Kauppinen: p. 13t.l.
Kakslauttanen Arctic Resort: p. 17 (3)
Elisa Karhula: p. 18 (2)
Esa Siltaloppi: p. 20 (4), 23
Kent Lindvall: p. 25t.l.
Johan Seijbel: p. 27t.r.
Viggo Lundberg: p. 27t.r.
Kolarbyn Eco Lodge: p. 30t.l.
Lasse Modin: p. 30r.o.
John van Helvert: p. 30b.
Ayet Alers: p. 33 (3)
Stine Christiansen: p. 35 (3), 36
Isaac Hegna Mannig: pp. 38t. (2), b.l., 41
Nils Petter Dale: p. 38b.r.
Gluba Treetop Cabins: p. 42 (3)
Sky Sighting Iglúhús: p. 44 (3)
Kristjan Maack: p. 47 (2)
Joe Putman: S. 50 (4)
The Oxford Yurt: p. 55 (2)
Julie Magnussen Photography: p. 56 (4)
fforest archives: p. 61t.l., b.
Heather Birnie: p. 61t.r., 62
George Fielding: p. 64 (2)
Tobias Mittmann: p. 69b.
www.baumgefluester.de: pp. 69t. (2), 70
Tree Inn: pp. 72 (3), 75
Friederike Hegner: p. 76 (2)
Cloefhänger: pp. 79t., 80
Franz Weiser: p. 79b.
Julian Stolte: p. 83t.
Susanne Schug: p. 83b., 85
Ryan Doyle Vision 360: p. 86 (2)
Rob Ranney: p. 88
It Dreamlân: p. 90 (3)
De vreemde Vogel: p. 93 (3)
Instagram.com/theblisshunter: p. 94 (2)
Nutchel: p. 96 (3),
Trixe den Breuls: p.96 t.t.
Ruben Visserthooft: p. 99
Les Cabanes de Marie: p. 100 (3)
Les Ormes: p. 103 (2)
Amaia Maguregui de Echevarrieta: p. 107 (2)
Mart Hijmans: p. 108t.t., b., 111
Pieter D'Hoop: p. 108t.l.

Lelia Scarfiotti: p. 112t.
Rafal Bojar: p. 112b.
Veronica Rickert: p. 115 (3)
Finca les coves: p. 116t.l.
CLOVEUR: S. 116t.r., b.
Greetje Mulder: p. 119
NomadXperience: p. 120 (2)
Armonia Alpujarra: pp. 122b., 125
Lima Escape: p. 126t. (2)
Bukubaki Eco Surf Resort: p. 129 (2)
Quinta da Pacheca: p. 132 (2)
Quinta do Catalao: p. 135 (3)
Linden Tree: p. 136 (3)
Lake Shkodra Resort: p. 141 (3)
The Old Bus: p. 142 (3)
Agramada Hotel: p. 145 (3)
Holidayurt: p. 148 (3)
photo Glendoria: p. 153 (3)
Miroslav Ašanin: pp. 154t.l., 157
Joonas Linkola: S. 154t.r.
Nika Velikonja: S. 154b.
Garden Village Bled: pp. 159t., b.r., 160
Klavdija Zitnik: p. 159b.l.
Hunza Ecolodge: pp. 162 (3), 164
Homoki Lodge: p. 167 (3)
Julian Hartley: S. 168 (3)
Oaktreehouse: p. 170 (3), 173
alexchitu.ro: p. 175t.l.
Transylvania Log Cabins: p. 175t.t., b. (2)
VarenaTreehouse: p. 176 (4)
Eve Naaber: p. 179 (3)
Margus Vilisoo: p. 182t.l., b. (2)
Oskats Briedis: p. 184, p. 186
Arturs Laucis: p. 188 (3)

Mauritius Images: p. 53 (Alamy / Graham Turner), 58 (Alamy / Maurice Crooks)

Shutterstock: pp. 10/11 (Kat Buslaeva), 27b. (Michael715), 28 (Scandphoto), 48/49 (photolinc), 67 (Helen Hotson), 104/105 (maljuk), 122t. (joserpizarro), 126b. (Peek Creative Collective), 130 (Lmspencer), 138 (goran_safarek), 146/147 (Anassia Art), 150 (DaLiu), 180 (Elvin Heinla), 182t.r. (Kirk Fisher)

Originally published as *Glamping* by © Bruckmann Verlag, GmbH, Munich
Translated from the German by Dr. Katrin Binder.

Library of Congress Control Number: 2022944291

Edited by Ian Robertson
Designed by Christopher Bower
Cover design by Christoper Bower
Front cover image: Susanne Schug.
Back cover images: *Left*: Friederike Hegner, *right above*: Quintado Catalao, *right below*: Arturs Laucis
Endsheet images: Rafal Bojar.

Type set in Verdana

ISBN: 978-0-7643-6600-0
Printed in China

Published by Schiffer Publishing, Ltd.
4880 Lower Valley Road
Atglen, PA 19310
Phone: (610) 593-1777; Fax: (610) 593-2002
Email: Info@schifferbooks.com
Web: www.schifferbooks.com

For our complete selection of fine books on this and related subjects, please visit our website at www.schifferbooks.com. You may also write for a free catalog.

Schiffer Publishing's titles are available at special discounts for bulk purchases for sales promotions or premiums. Special editions, including personalized covers, corporate imprints, and excerpts, can be created in large quantities for special needs. For more information, contact the publisher.

We are always looking for people to write books on new and related subjects. If you have an idea for a book, please contact us at proposals@schifferbooks.com.

FSC
www.fsc.org
MIX
Paper | Supporting responsible forestry
FSC® C104723

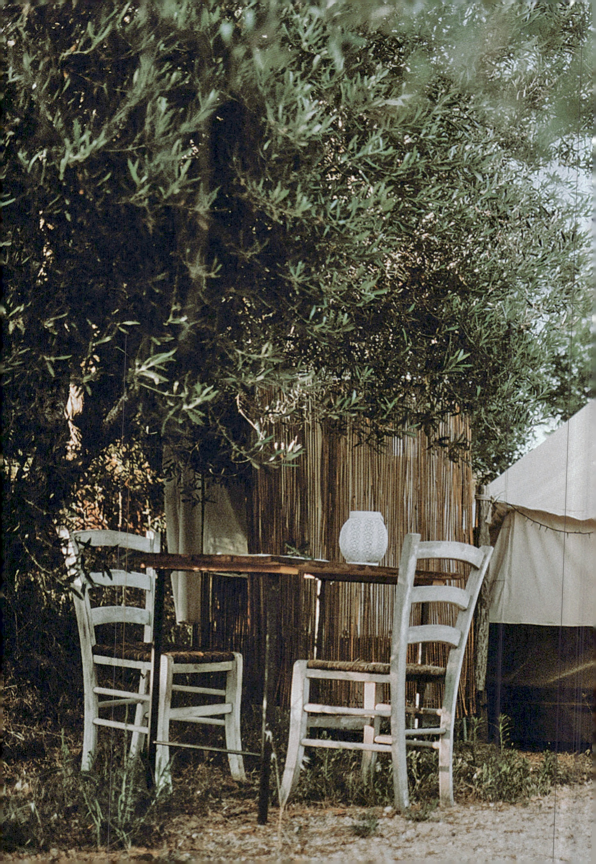